Nara Buddhist Art:
Todai-ji

Volume 5

THE HEIBONSHA SURVEY OF JAPANESE ART

For a list of the entire series see end of book

CONSULTING EDITORS

Katsuichiro Kamei, *art critic*
Seiichiro Takahashi, *Chairman, Japan Art Academy*
Ichimatsu Tanaka, *Chairman, Cultural Properties Protection Commission*

Nara Buddhist Art: Todai-ji

by TAKESHI KOBAYASHI

translated and adapted by
Richard L. Gage

New York · WEATHERHILL/HEIBONSHA · Tokyo

This book was originally published in Japanese by Heibonsha under the title *Todai-ji no Daibutsu* in the Nihon no Bijutsu series.

A full glossary-index covering the entire series will be published when the series is complete.

First English Edition, 1975

Jointly published by John Weatherhill, Inc., 149 Madison Avenue, New York, New York 10016, with editorial offices at 7-6-13 Roppongi, Minato-ku, Tokyo 106, and Heibonsha, Tokyo. Copyright © 1964, 1975, by Heibonsha; all rights reserved. Printed in Japan.

Library of Congress Cataloging in Publication Data: Kobayashi Takeshi, 1903–1969 / Nara Buddhist art, Tōdai-ji. / (Heibonsha survey of Japanese art; v. 5) / Translation of Tōdai-ji no Daibutsu. / 1. Sculpture, Buddhist—Nara, Japan (City) 2. Sculpture—Nara, Japan (City) 3. Tōdai-ji, Nara, Japan. / I. Title. II. Series. / NB1057.N36K6213 732'.7 74-22034 ISBN 0-8348-1021-2

Contents

Nara Buddhist Art:
Todai-ji

Prologue

IN THE MISTY PAST, the Japanese people lived in scattered groups called *uji,* a word that is only imperfectly translated by the English word "clan." Much of the early history of what was to become the Japanese nation is the story of how one of these *uji,* the Yamato clan, gradually attained preeminence and, after several centuries, established the imperial line.

The Japanese themselves had no writing until they adopted Chinese ideographs, of which they already had knowledge in the fifth century A.D. Even the two famous chronicles of early Japanese history, the *Kojiki* (Record of Ancient Matters), dating from 712, and the *Nihon Shoki,* or *Nihongi* (Chronicles of Japan), dating from 720, were written in Chinese script with a partly Chinese vocabulary. We also have other records of ancient Japan because the Chinese themselves, always diligent compilers of encyclopedic collections of knowledge, did not fail to make comments indicating that the unification of the Japanese clans had possibly begun in the third century A.D. Chinese example doubtless spurred the acceleration of this process.

Contacts between China and Japan had been maintained since as early as prehistoric times. The immigration of Koreans knowledgeable in Chinese culture had provided the relatively backward Japanese with much information and possibly with the desire to emulate their great continental neighbor. Full-scale borrowing from China took place in the early seventh century, and political stability was almost certainly among the attractive ideas that Japanese leaders found in the imported knowledge. Such stability was important to a nation that was still no more than a loose organization held together only by the insecure dignity of the Yamato clan, which could by no means claim true superiority over its fellow clans. Three factors combine here to form a clear picture of a nation in need of a way to put governing power into the hands of one group or person: the Japanese awareness of the glories of Chinese civilization—the product of a firm central government; the possible threat of an increasingly strong and united Korea; and the continuing upheaval caused in Japanese politics by the rivalries and squabbles among the numerous clans.

In many instances in the civilization of man, religion has been a source of the power of political rulers. Shinto, the indigenous religion of Japan, certainly influenced the role played by clan heads. For example, the leader of the Yamato clan was always associated with the sun, represented by the goddess Amaterasu, who was considered the ancestor—however remote—of the imperial family. But in the early phases of Japanese unification, Shinto lacked the ability to bring all factions together, since it is itself a highly diffuse form of nature worship in which *kami,* or gods, are innumerable and are ungoverned by any prevailing philosophy or ethic.

In the sixth century—traditionally in 552, al-

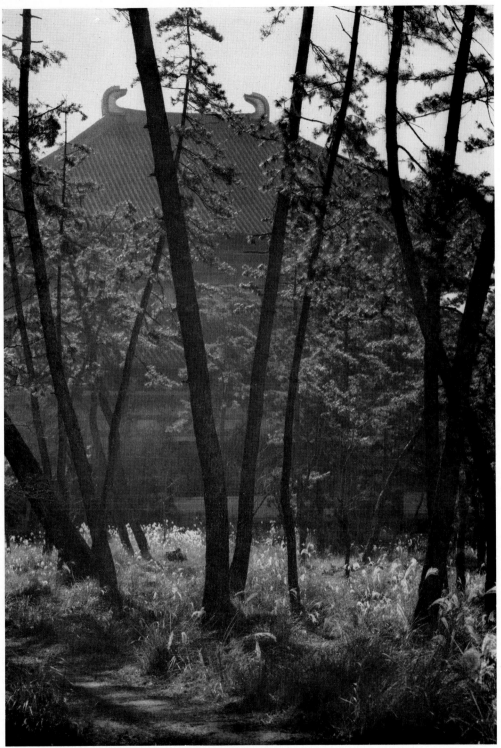

1. Great Buddha Hall (Daibutsuden) viewed from site of former Lecture Hall, Todai-ji, Nara.

hough some scholars put the date earlier—Japan made perhaps the most important of all its borrowings from China: Buddhism. When this originally Indian religion reached the Japanese islands by way of Korea, it was already ancient. Gautama Siddhartha, who was known as Sakyamuni (in Japanese, Shaka), or the Sage of the Sakyas, and eventually became the Buddha, the Enlightened One, was born in the sixth century B.C. The Buddhism that moved northward through China and Korea was what is called Mahayana, or Northern, Buddhism. It has an immense canonical literature, a dazzling art, a subtle philosophy, and a bewildering pantheon of gods, other divinities, and extraordinary beings borrowed from Hinduism and other religions.

It seems unlikely that the Japanese of the sixth century were either trained or inclined to battle with the complexities of fully developed Buddhist thought. But this did not matter, for Buddhism was to become the core around which political and religious authority was to be united.

During the first few decades after its introduction into Japan, Buddhism did not fare entirely well. The conservative Nakatomi clan of Shinto priests and the Mononobe clan of warriors were adamantly opposed to the adoption of the new religion. The Soga clan, who took to Buddhism at once, met with religious and political defeat for a while, but in 587 there occurred two events that made the future of Buddhism in Japan secure. First, the emperor, the nephew of the most powerful figure of the Soga clan, became a Buddhist immediately before his death. Second, the Soga, with the assistance of the Otomi military clan, routed all their enemies. They happily attributed their victory to the power of the Buddhist gods, and for several centuries afterward Buddhism had no rival in the highest Japanese aristocracy.

During the seventh century, the devout Buddhist empress Suiko—a Soga—and her nephew and regent, Prince Shotoku, did much to lay the foundations for a Chinese-style government and an extensive reverence for Buddhism throughout the land. As part of their varied activities, they built several temples, among which was the famous Horyu-ji, some of whose buildings remain today as the oldest examples of wooden architecture in the world. The political policies of Prince Shotoku were allowed to lapse after his death until two great leaders, Fujiwara Kamatari* and the emperor Tenji, made drastic changes in the national administration and thus succeeded in unifying the major part of the nation under firm authority and in a governmental system closely based on Chinese models.

I have briefly sketched the line of development through which Japan grew from a primitive grouping of clans, with the Yamato clan enjoying preeminence but not total power, into a Chinese-style government officially patronizing Buddhism and exercising control over the most advanced part of the country. In the following chapter I shall explain how Buddhism was used in an attempt to unify national religion and thus secure divine protection for Japan as a whole. This project stimulated a wave of artistic production of the highest quality. In this book I write mainly of the sculpture of what is called the Nara period (646–794). Before turning to that story, however, I must explain the art subperiods with which the book will deal.

The art of the Nara period falls into three divisions. Early Nara art embraces the products of the time preceding the ascension of Shomu to the imperial throne in 724. The middle Nara period, in which most of the great works of sculpture described in the following pages were produced, covers the reign of the same emperor, which lasted until his retirement in 749. The late Nara period, in which the vigor of the art began to decline, lasted from 749 until 794, when the capital of the nation was established at Heian-kyo (the modern Kyoto). It should be noted that although Nara ceased to be the capital in 784, when the court moved to Nagaoka for a period of ten years, the closing year of the Nara period is generally considered to have been 794.

* The names of all Japanese in the text are given, as in this case, in Japanese style (surname first).

CHAPTER ONE

Buddhism as a Unifying Force

STEPS TOWARD UNIFICATION The story of the eighth century in Japanese history is a tale of attempts to unify the nation and to gain power. The three contending forces in the story are the imperial throne, which all too often ranked third in the race; the aristocracy, especially the powerful Fujiwara family; and the clergy, which can be symbolized by the Todaiji, a monastery-temple of such tremendous dimensions that its construction nearly bankrupted the country.

Throughout the period when the capital of the nation was the city now called Nara (it was known as Heijo-kyo in the eighth century), religious means were sometimes used to achieve political ends. As has been noted in the Prologue, by the end of the seventh century a Chinese-style government had been more or less established, but there was still much work to be done to bring the nation under the control of that government. Legally, the Taika Reforms, promulgated in 646 during the reign of the emperor Kotoku, extended the control of the central government to all provinces. After the succession war called the Jinshin Rebellion (672), the authority of the imperial court was at last firmly established, and it seemed that the nation could be unified in fact as well as in theory. Although it was not a simple task to accomplish this feat, various efforts were made.

The emperior Temmu (reigned 673–86) took both religious and secular steps in the hope of tightening the governmental grip on the remote parts of the country. In 676 he sent copies of the *Sutra of the Golden Light* (in Japanese, *Konkomyo-kyo*) to all provinces. In 681 he ordered the repair of Shinto shrines in all provinces, and in 684 he sponsored revisions of the family names of everyone in Japan according to a system in which there were only eight recognized surnames. In 694 the empress Jito (reigned 690–97) sent out further copies of the *Sutra of the Golden Light*. She also established the capital at Fujiwara, in what is now north-central Nara Prefecture.

According to Japanese tradition, influenced no doubt by Shinto purification rituals and obsession with cleanliness, death is considered polluting. In the distant past, when an emperor died, the capital was changed in order to avoid the baleful influences of his decease. This made little difference to governmental efficiency at the time, since the machinery of administration was primitive and simple. But as the nation came to exist as a unity and as the tasks of the officials grew more elaborate, this system became impractical. The empress Jito had attempted to fix the capital but failed in her efforts. Her successor, the emperor Mommu (reigned 697–707), had somewhat better luck.

He, too, did his utmost to extend the power of the government and turned to religious measures for assistance. In 701 he promulgated a legal code based on the Taika Reforms of 646 and called the Tairitsuryo, or Great Legal Code. In the following

. Distant view of Great Buddha Hall (Daibutsuden), Todai-ji, Nara. The pagoda in the background is that of the Kofuku-ji.

ear he sent priests to each province to supervise regional Buddhist affairs. He also ordered that the capital of the nation be permanently established at Nara, but the move was not made until 710, three years after his death.

THE EMPEROR SHOMU AND THE FUJIWARA

At his death, the emperor Mommu left a young son named Obito. Before this boy could become the emperor Shomu, found the Todai-ji, and thus provide the impetus for a dazzling cultural and artistic efflorescence, two empresses—one his grandmother and one his aunt—were to hold the throne, and he was to undergo a lengthy course of education under the tutelage of the Fujiwara, the most influential family at the imperial court.

At this time the Fujiwara were already plying their considerable political skills and marrying their young daughters to members of the imperial family. Their diplomatic adroitness and their supply of marriageable females were to prove the assets by means of which they held power in Japan for centuries, with only occasional lapses. At the time of the minority of Prince Obito, the leading member of the clan was Fujiwara Fuhito, who undertook the education of the prince and brought him up together with his own daughter Komyo. When Obito was seventeen, a marriage was contracted between him and this young lady, with whom he had lived on an almost brotherly footing for some time. It was looked upon with chagrin by the aristocratic families who were rivals of the Fujiwara, but they were powerless to prevent it.

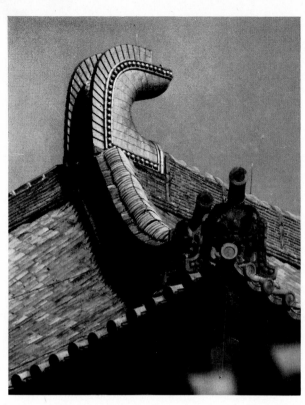

3. Shibi *(ridge-end ornament) on roof of Great Buddha Hall (Daibutsuden), Todai-ji, Nara.*

4. Basara Taisho, one of the Twelve Godly Generals. Painted clay; height of entire statue (see Figure 152), 166.8 cm About 748. Main Hall, Shin Yakushi-ji, Nara. (See also Figures 91, 109.)

The rival factions in the capital and the rest of the country, although overwhelmed by the Fujiwara, were not entirely subdued. The age was one in which discontented parties instigated frequent uprisings and disorders that had to be put down with dispatch. But Prince Obito had been raised in a pacific atmosphere of devotion to culture and learning. He preferred a world removed from the sordid world of politics. Consequently, when he assumed the imperial responsibility in 724 and became the emperor Shomu, he isolated himself from the unrest of the court by indulging in frequent travel and hunting parties throughout the Yamato Plain.

The Fujiwara were probably not displeased by the young emperor's preference for being away from the court, for it gave them a free hand to do as they liked. They enjoyed one very good stroke of luck in 727, when Komyo gave birth to a boy who was called Prince Motoi and was immediately made crown prince. This event did much for the standing of Komyo, who was not at that time the empress but only one of the emperor's wives. Things turned dark for the Fujiwara, however, when the infant prince died in 728. Soon after this, the birth of a son to another of the emperor's wives compelled the Fujiwara to act in order to make Komyo the empress and thus place her in a position that carried the same prestige and offered the same prospect in the line of inheritance as that of the crown prince. After some fighting and bloodshed the Fujiwara clan overcame stiff opposition and had Komyo installed as empress in 729.

But this did not mean that all would be placid

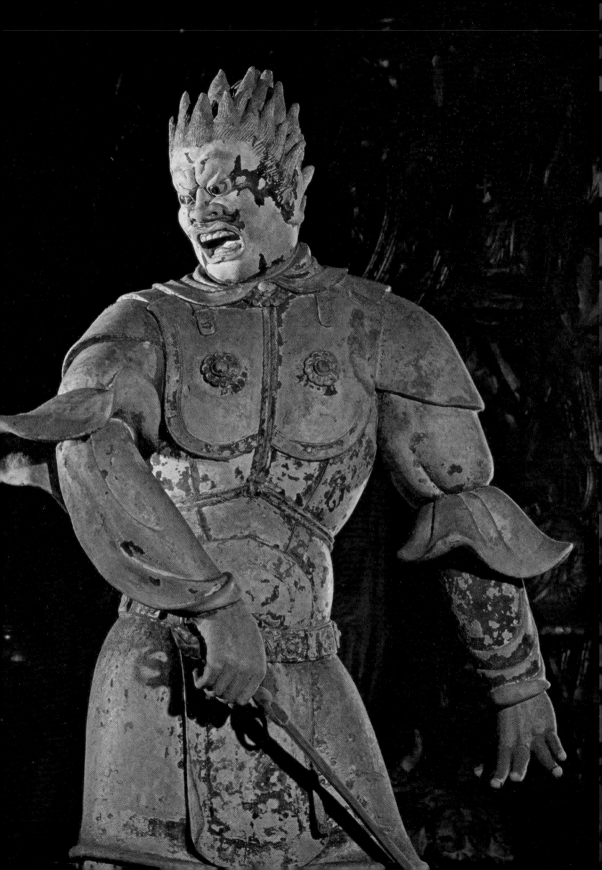

5. *Fukukenjaku Kannon. Dry lacquer with colors; height of entire statue (see Figure 48), 360.6 cm. 746. Sangatsudo, Todai-ji, Nara. (See also Figures 14, 15, 19, 20, 44, 46, 49, 127.)*

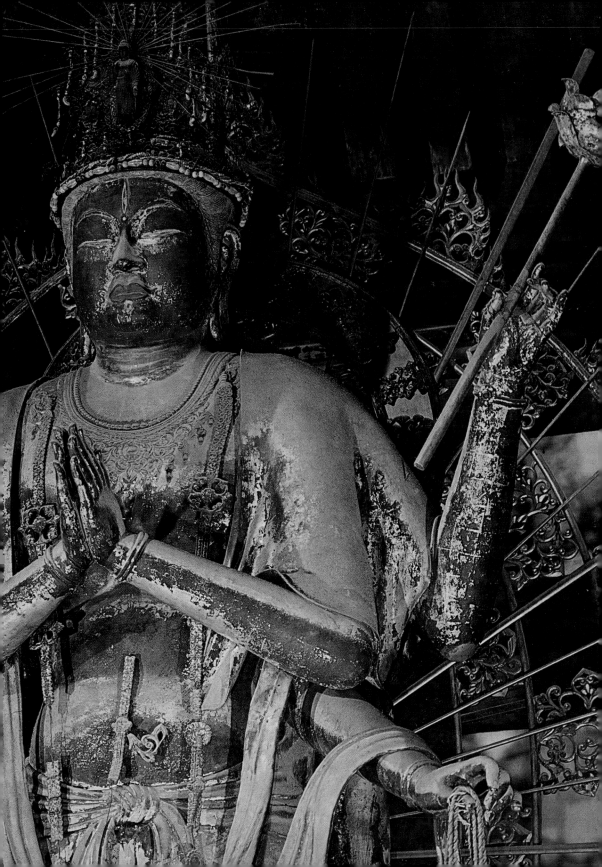

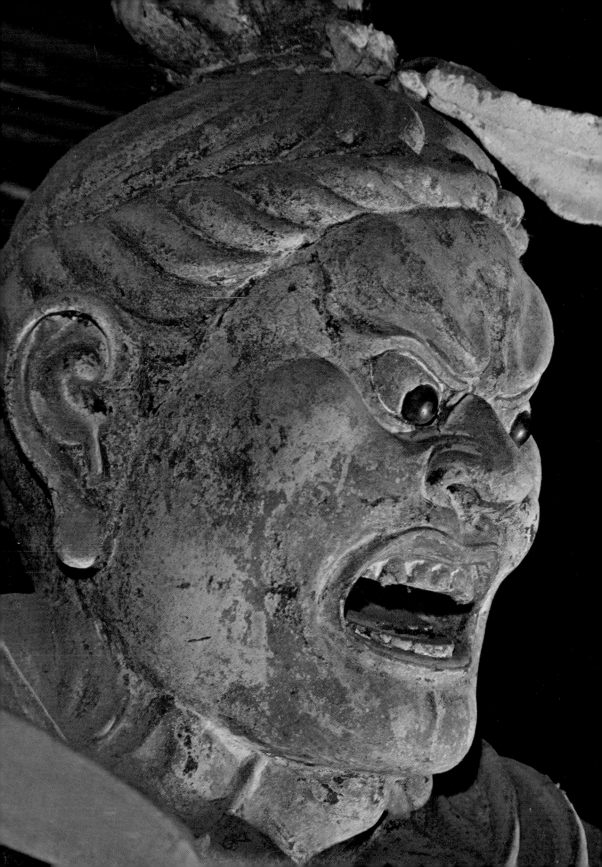

. *Shikkongo Shin. Painted clay; height*
f entire statue (see Figure 12), 167.5 cm.
bout 733. Sangatsudo, Todai-ji, Nara.
See also Figures 13, 117.)

7. Oni-gawara *(demon tile) ridge-end
ornament on roof of Great Buddha Hall
(Daibutsuden), Todai-ji, Nara.*

or the Fujiwara and for the nation. Uprisings continued in the provinces and soon grew so violent in the Yamato region itself that the emperor had no recourse but to curtail his travels and live in the capital. Although he largely gave up hunting and entertaining, banquets and similar gatherings did not stop in the palace. Now, however, they entered around the empress Komyo, her Fujiwara associates, and influential members of the Buddhist clergy.

Suddenly there occurred a great calamity, more horrifying than the uprisings of the malcontents in the provinces: an epidemic arrived in southern Japan, apparently from the Korean peninsula. Word of numerous deaths among farmers in Kyushu alarmed the capital. The Shinto gods and the Buddhas were invoked, but to no avail. Before long the sickness attacked the capital itself. High-placed people in the court fell ill. The Fujiwara family itself suffered a staggering blow in the loss of four politically active and influential sons. One of the several Buddhist priests who enjoyed prestige in the palace worked an apparently miraculous cure on a member of the loftiest aristocracy, and this feat enhanced his standing in court circles. Counsel from such influential clergymen and the grim situation he faced on all sides doubtless drove the emperor further in the direction of piety and religion.

Famine followed plague, and the rebelliousness of factions in the surrounding provinces continued unabated. The emperor quite naturally felt a pressing need for efficacious protection for the people and the nation. The unsettled nature of the times made him abandon Nara for the time

being and move the imperial residence from place to place. It was quite clear that some effective action had to be taken.

THE ESTABLISHMENT OF PROVINCIAL TEMPLES

Of course the emperor had not remained idle until this time. On the contrary, for years he had been taking steps that he thought would be helpful. In 728 he dispatched copies of the *Sutra of the Golden Light* to the provinces. In the spring of 737 he ordered each province to install in a local temple a sculptural group representing Sakyamuni and two attendant figures. At the same time he commanded that people in the provinces make copies of six hundred fascicles composing one set of the *Nehan-kyo,* or *Nirvana Sutra.* Early in the summer of 740 each province was instructed to make a copy of the *Hoke-kyo,* or *Lotus Sutra,* to build a seven-storied pagoda, to erect a statue of the Bodhisattva Kannon (Avalokitesvara), and to make a copy of the ten fascicles of the *Kannon Sutra* (actually a chapter of the *Lotus Sutra*). Still, no matter how diligently the emperor did what he thought was right, the desired improvements failed to take place. In 743 he decided to resort to the strongest measures to date: an imperial order decreeing the establishment of a monastery-temple and a convent-temple in each province. These temples were known in general as *kokubunji* (literally, "provincial temples").

The purpose of the *kokubunji* was to inspire national unity and peace through religious services, especially those devoted to the Four Celestial Guardians (Shitenno), who, in the *Sutra of the Golden Light,* promise to guard the faithful, to protect their lands from disaster and damage, and to grant them immense blessings and happiness. In order to avail Japan of these good things, the emperor instructed that the *Sutra of the Golden Light* be read in each *kokubunji* on the eighth day of each month.

The imperial order commanding the building of the *kokubunji* reveals how seriously the emperor Shomu took the project. He begins the order by expressing his shame that his own lack of virtue has hindered the smooth administration and general prosperity of the country. He then goes on to recount the pious steps he has already taken to rectify his faults. He mentions his instructions to beautify the existing temples and shrines of the nation and his orders concerning the making of statues of Sakyamuni and the copying of sutras. After showing gratitude for the recent abundant harvest that these efforts seem to have produced, he adds a description of his instructions to build pagodas and enshrine copies of the *Sutra of the Golden Light* in the hope that the Four Celestial Guardians will grant the nation their favor. He then explains the building of the *kokubunji* and requests the assistance of people near and far in their construction. Finally he lists the lands to be granted to the monasteries and convents for their sustenance and stipulates fast days and days on which the *Sutra of the Golden Light* must be read.

PLANS FOR CONSTRUCTING THE GREAT BUDDHA

In spite of these detailed instructions and enthusiastic encouragement from the throne, the building and the management of the *kokubunji* were not entirely in keeping with the emperor's wishes. Observing the slow response to his orders, in midautumn of 743 Shomu decreed the construction of a colossal statue of the Buddha Vairocana (in Japanese, Birushana), a cosmic Buddha who rules over myriads of worlds, each presided over by a Buddha. Vairocana was an apt symbol of the emperor as the controlling head of the state.

It was quite natural for Shomu to call on the aristocrats and the rich for assistance in the project, but he also issued a plea for the cooperation of people of lowly status. Though it would require great effort, the work promised benefit for the nation. He commanded that the bronze of the country be exhausted to make the statue and that, if necessary, hills be leveled to provide a place for the hall that would house it. Convinced that the project would bring good to all, he made it clear that everyone throughout the land was invited to participate in it.

As we have already noted, Shomu was moving

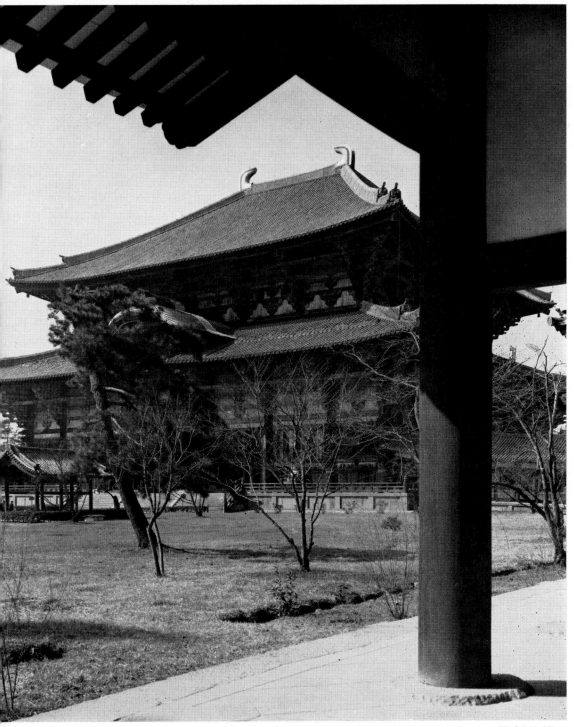

8. Great Buddha Hall (Daibutsuden) viewed from kairo *(corridor) surrounding forecourt, Todai-ji, Nara.*

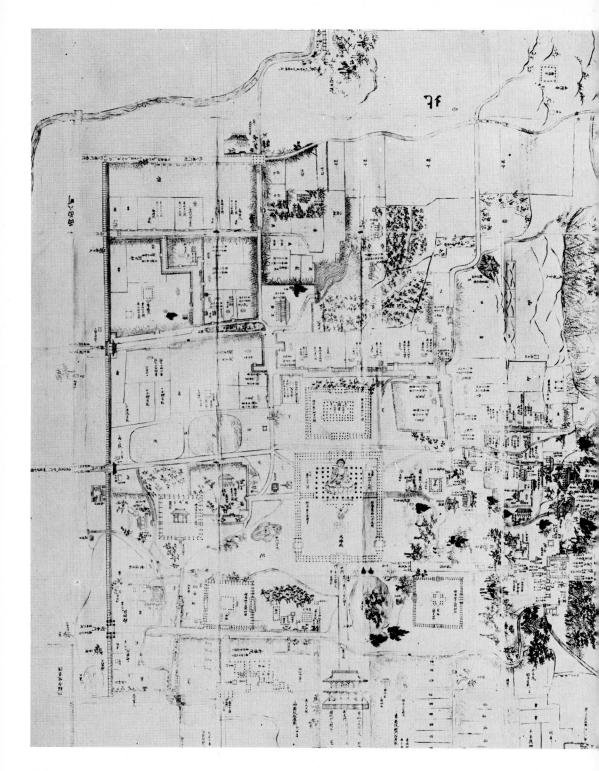

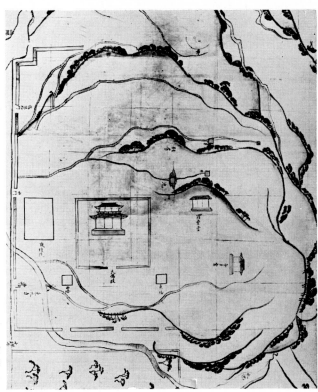

10. Map of Todai-ji made at time of its construction. Paper reproduction of linen original made in 756. Shoso-in, Todai-ji, Nara.

he imperial residence from place to place at this time. Originally the gigantic statue of Vairocana— he Great Buddha, as it came to be called—was o be constructed at a place in Omi Province called higaraki, then the site of the imperial palace. But hortly after work began, a strange series of disasers occurred. Numerous fires, some of which are elieved to have been deliberately set, and an arthquake in 745 were among the happenings hat convinced everyone, including the emperor imself, that the place was unpropitious. The plan vas changed, and it was ordered that the statue e constructed in Nara.

Before we move on to the second stage in the reation of the statue and the culture it symbolizes, et us note the three motivating factors that seem

likely to have inspired the emperor to launch this costly and time-consuming undertaking. It has already been pointed out that as part of the general effort to unify both the nation and religion, Vairocana, the cosmic Buddha, was an especially valuable political and religious symbol. In addition, influential court priests in all likelihood exerted pressure on the emperor to carry out this pious work, and they probably reached him most effectively through the good offices of the empress Komyo, whose ear they no doubt had at all times. Finally, it would be wrong to overlook the possibility that Shomu wanted to produce a work in Japan that could compare in grandiose scale with such famous Chinese monuments as the cave temples of Lungmen.

Before the Completion
of the Great Buddha

THE KINSHO-JI AND THE SHIKKONGO SHIN The system of provincial temples (*kokubunji*) established by the emperor Shomu extended over much of the nation. At first, what is now called the Todai-ji was only the provincial temple for the province of Yamato (the present Nara Prefecture). Later, however, it became the most important temple in the entire network and the foremost religious institution in the country. It is possible to pin down the date of the change in status of the temple by examining the records of the organizations in charge of the construction and decoration of its buildings. In its earlier stages the Yamato *kokubunji* was called the Konkomyo-ji after the *Sutra of the Golden Light* (*Konkomyo-kyo*), and responsibility for its construction lay with an organization called the Bureau for the Construction of the Konkomyo-ji. After 747, that organization is listed in the records as the Bureau for the Construction of the Todai-ji.

Recent research has corroborated longstanding evidence to the effect that the original provincial temple for Yamato was the Kinsho-ji, located in the eastern hills of Nara. It is certain that this temple was to some extent refurbished to serve a more important role, but details about the time of building and the size of the temple are un-available. According to an ancient record calle[d] the *Todai-ji Yoroku*, the Kinsho-ji was built in 73[] The oldest collection of Japanese Buddhist tale[s] a book called the *Nihon Ryoiki*, written about 82[] by the priest Keikai, tells us something about th[e] temple and possibly about a famous statue of th[e] guardian deity Shikkongo Shin (Vajradhara), o[r] Shukongojin, as he is sometimes called, that [is] housed today in the Sangatsudo (Third-Mont[h] Hall; also called the Hokkedo, or Lotus Hall) o[f] the Todai-ji (Figs. 6, 12, 13, 117). It should b[e] noted that in the *Nihon Ryoiki* account the Kinsho[-] ji is called the Kinshu-ji, and this is the name use[d] in the two paragraphs immediately below, sinc[e] they derive from the information given in th[at] account.

The story goes that there was a temple in th[e] eastern hills of Nara that came to be called th[e] Kinshu-ji after a male Buddhist lay devotee, late[r] named Kinshu, who lived there. This temple, say[s] the *Nihon Ryoiki*, eventually became the Todai-j[i.] The devout layman had a statue of Shikkong[o] Shin installed in the temple. Around one leg o[f] the statue he tied a rope, at which he tugged a[s] he sat in prayer. From time to time, it was sai[d] light shone from the leg, and word of this miracu[-] lous occurrence reached the imperial palace. Whe[n] he heard of it, the emperor Shomu immediatel[y]

11. *Detail of Sangatsudo (Third-Month Hall). About mid-eighth century.*
Todai-ji, Nara.

ispatched a courier to investigate, and the courier
astened to fulfill his commission. Upon seeing the
ayman at his prayers and the light shining from
ne leg of the statue, he was convinced that rumor
old the truth. He hurried back to the palace,
where he told the emperor what he had seen, and
ne emperor sent at once for the pious layman to
y to discover what the reason for the miracle
might be. After listening to all that the layman
ould tell him, the emperor granted him permis-
on to become a priest and gave him the name
.inshu.

The story of Kinshu reveals two important
nings: first, that there was a temple called the
.inshu-ji in the eastern hills of Nara before the
onstruction of the Todai-ji and, second, that in
ne temple was enshrined a clay statue of Shikkongo
hin. The statue that now stands in the Sangatsudo

of the Todai-ji may or may not be the one that is
said to have been worshiped by Kinshu, but aside
from its possible connection with that saintly man,
it is a superlative work of art, even by the high
standards of the Nara period. More or less life-
sized (its height is 167.5 centimeters), the painted
clay figure is based on Chinese styles of the T'ang
period (618–906), but it was created by Japanese
artists. Therefore it is part of the mainstream of
the art styles of the Nara age. In the varying ex-
pressions of the face, as it changes with the quality
of the light and the angle of vision, one can sense
an elusive brightness. The methods used to pro-
duce the figure were highly refined, and the intense
care taken in the treatment of the clay is probably
one of the reasons why the statue has been pre-
served in almost original appearance for more than
twelve centuries. Much of the exquisitely designed

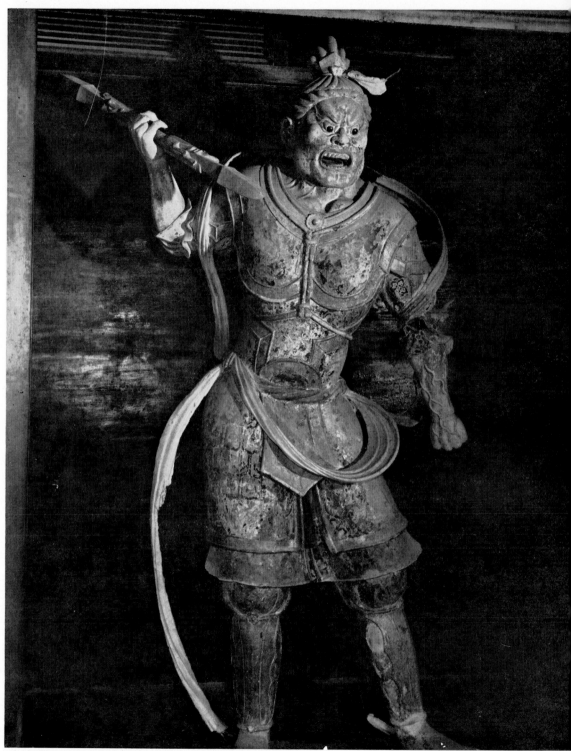

12. *Shikkongo Shin. Painted clay; height, 167.5 cm. About 733. Sangatsudo, Todai-ji, Nara. (See also Figures 6, 13, 117.)*

13. *Detail of Shikkongo Shin. Painted clay; height of entire statue (see Figure 12), 167.5 cm. About 733. Sangatsudo, Todai-ji, Nara. (See also Figures 6, 117.)*

and beautifully executed floral and scroll patterns on the garments is still visible.

THE FUKUKENJAKU KANNON AND ITS ACCOMPANYING STATUES In 741 the Kinsho-ji (as we shall henceforth call it) was designated the *kokubunji* of Yamato Province, but it is probable that the order did not actually go into effect until 742. It is impossible to know what changes this designation made in the character or the appearance of the temple. If we judge by the nature of the topography, it seems likely that the present Sangatsudo of the Todai-ji was the main hall of the Kinsho-ji. In addition, the dry-lacquer statue of the Fukukenjaku Kannon (Amoghapasa) housed

in the Sangatsudo today (Figs. 5, 14, 15, 19, 20, 44, 46, 48, 49, 127) was probably the original main image of the Kinsho-ji and was most likely produced in compliance with the edict of 740 ordering temples to produce statues of Kannon.

The Fukukenjaku (or Fukukensaku) Kannon, one of the seven manifestations of the Bodhisattva Kannon popular in Japan, is represented in the Sangatsudo by a dry-lacquer figure that is an example of the most sophisticated sculptural techniques of the age in which it was produced. It was considered a very large work when it was completed, its height being 360.6 centimeters. Japanese artistic perception and sense of form combine here to create an ideal representation of this compassionate Bodhisattva.

14. *Detail of mandorla of Fukukenjaku Kannon. Colors on wood. 746. Sangatsudo, Todai-ji, Nara. (See also Figures 5, 15, 48.)*

15. *Fukukenjaku Kannon with Nikko Bosatsu (foreground) and Gakko Bosatsu (background). Fukukenjaku Kannon: dry lacquer with colors; height, 360.6 cm.; 746. Nikko Bosatsu and Gakko Bosatsu: painted clay; heights, 226.1 cm. and 224.4 cm., respectively; 742–46. Sangatsudo, Todai-ji, Nara. (See also Figures 5, 48–51, 108, 129, 130.)*

Although today the group of statues surrounding the Fukukenjaku Kannon includes large dry-lacquer figures of Bon Ten (Brahma; Figs. 52, 135), Taishaku Ten (Indra; Fig. 134), the Four Celestial Guardians (Figs. 56–59, 77, 136, 137), and the Kongo Rikishi (Vajrapani, Ni-o, or Benevolent Kings; Figs. 54, 55, 67, 69), it is likely that these are not part of the original attendant figures. When it was first installed, the set probably consisted of the clay statues of Bon Ten and Taishaku Ten now commonly called the Nikko Bosatsu (Suryaprabha, or Sunlight Bodhisattva; Figs. 16, 51, 129) and the Gakko Bosatsu (Candraprabha, or Moonlight Bodhisattva; Figs. 45, 50, 108, 130) and the clay statues of the Four Celestial Guardians now housed in the Kaidan-in of the Todai-ji (Figs.

17, 18, 21, 22, 60, 61, 138–141). It should be noted here that in this book, in deference to popular custom, the clay statues of Bon Ten and Taishaku Ten are referred to as the Nikko Bosatsu and the Gakko Bosatsu.

A number of reasons may be advanced to substantiate the assumption that the six above-noted clay statues comprised the original attendants of the Fukukenjaku Kannon. To begin with, although in terms of style the dry-lacquer statues no doubt belong to the mainstream of the Todai-ji Nara style, they display a laxness and a vagueness that while difficult to define, are immediately apparent. It is safest to date them somewhat later in the Nara period. In contrast with them, the clay statues are refined, compactly molded, and powerful in a

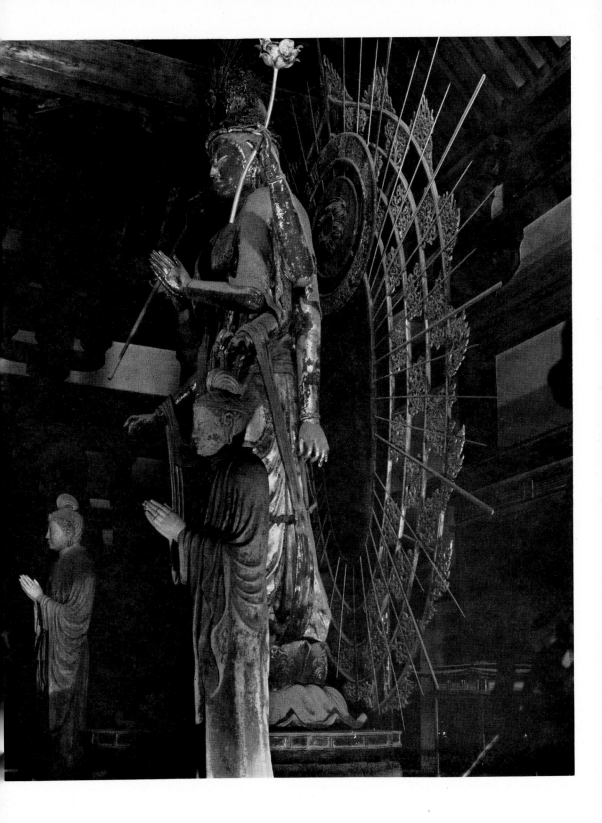

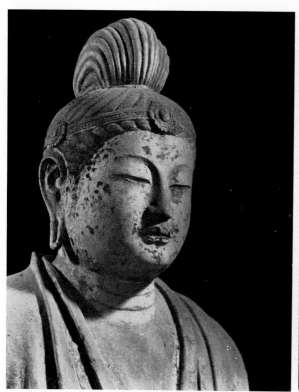

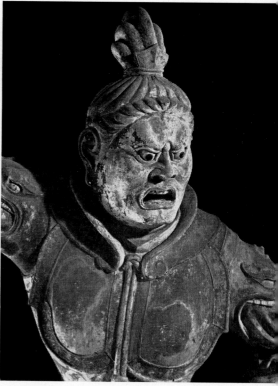

16. *Nikko Bosatsu. Painted clay; height of entire statue (see Figure 129), 226.1 cm. 742–46. Sangatsudo, Todai-ji, Nara. (See also Figures 15, 48, 51.)*

17. *Zocho Ten, one of the Four Celestial Guardians. Painted clay; height of entire statue (see Figure 141), 163.3 cm. 742–46. Kaidan-in, Todai-ji, Nara. (See also Figure 62.)*

strikingly youthful way. Their characteristics of form and mood seem to harmonize better with the Fukukenjaku Kannon.

Size, too, suggests that the six clay statues would create a more harmonious ensemble with the Kannon than the dry-lacquer statues now do. The dry-lacquer statues, which range from 333 to 394 centimeters in height, are too tall for the Kannon, but the Nikko Bosatsu (226.1 centimeters), the Gakko Bosatsu (224.4 centimeters), and the Four Celestial Guardians in the Kaidan-in (average height: 170.5 centimeters) are of appro-

priate size to complement a figure of the Kannon's height (360.6 centimeters).

It might seem logical to assume that the same material would be used throughout sets of temple statuary, and if this were invariably true, the case would be excellent for insisting that the dry-lacquer figures are the real companions of the Kannon. In fact, however, in Nara-period sculpture it is possible to find several examples of groups in which the central figure is of one material and the flanking subordinate figures of another. Consequently, there would be nothing at all peculiar in having a

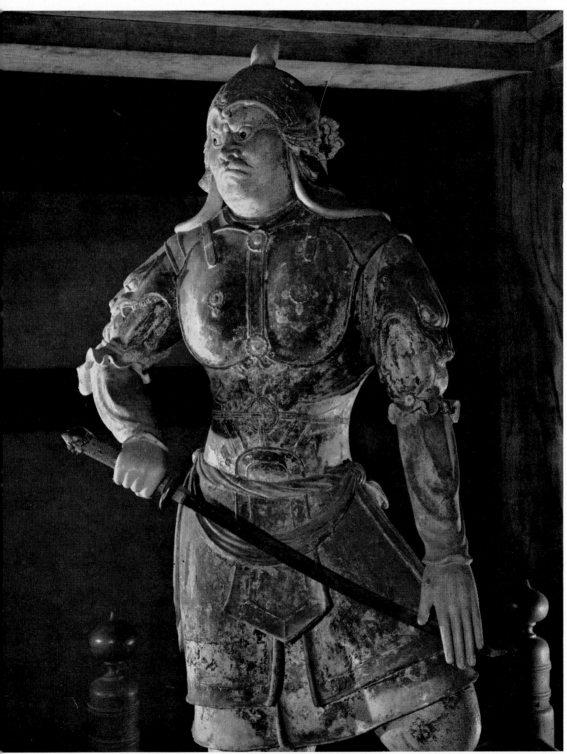

38. *Jikoku Ten, one of the Four Celestial Guardians. Painted clay; height of entire statue (see Figure 139), 178.2 cm. 742–46. Kaidan-in, Todai-ji, Nara. (See also Figures 22, 61.)*

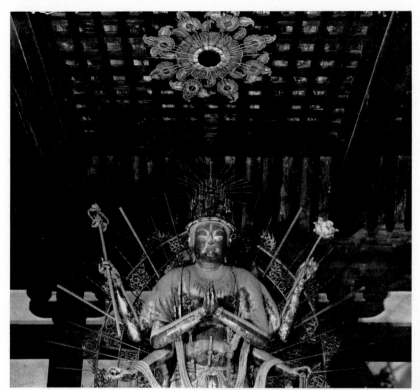

19. *Detail of Fukukenjaku Kann*
showing canopy. Kannon: dry lacq
with colors; height of entire sta
(see Figures 15, 48), 360.6 c
Canopy: colors on wood. 746. (
also Figure 113.)

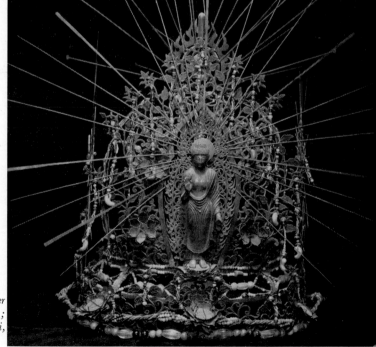

20. *Diadem of Fukukenjaku Kannon. Silver*
with magatama *(curved jewels) and beads;*
height, 24.2 cm. 746. Sangatsudo, Todai-ji,
Nara. (See also Figure 5.)

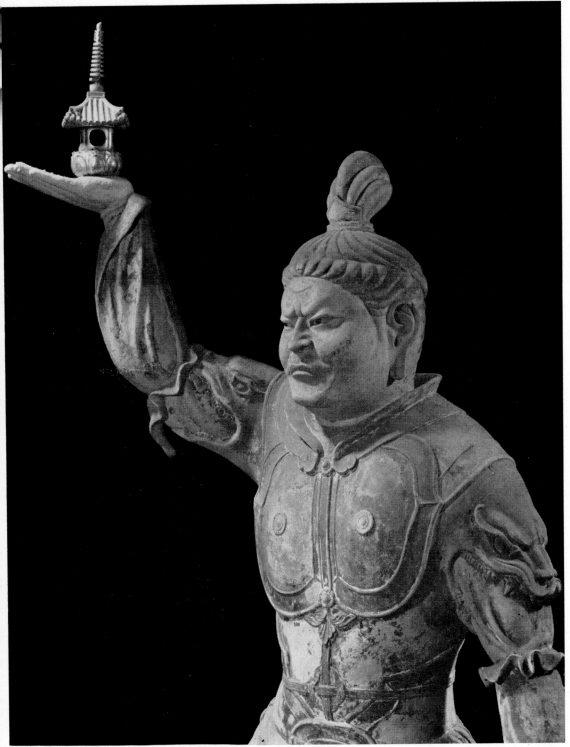

21. *Tamon Ten (also called Bishamon Ten), one of the Four Celestial Guardians. Painted clay; height of entire statue (see Figure 138), 176.9 cm. 742–46. Kaidan-in, Todai-ji, Nara.*

22. *Detail of Jikoku Ten, one of the Four Celestial Guardians. Painted clay; height of entire statue (see Figure 139), 178.2 cm. 742–46. Kaidan-in, Todai-ji, Nara. (See also Figures 18, 61.)*

dry-lacquer statue of Kannon accompanied by clay statues.

The so-called Nikko Bosatsu and Gakko Bosatsu, standing beside the Kannon with their hands joined in front of their chests in an attitude of prayer, have a formal brilliance that suggests great artistic accomplishment and a profundity of emotional expression that speaks directly and immediately to the heart of the viewer.

The same great technical skill has been used to produce the varieties of movement and expression that distinguish the Four Celestial Guardians in the Kaidan-in. The facial expressions are realistic and the costumes suggest the materials from which such clothing and armor would have been made. The entire group is a balanced blend of different moods ranging from the brightly active to the somber and deeply reflective. These statues, which are among the most outstanding of all Japanese representations of the Four Celestial Guardians, were certainly made during the period between 742 and 746.

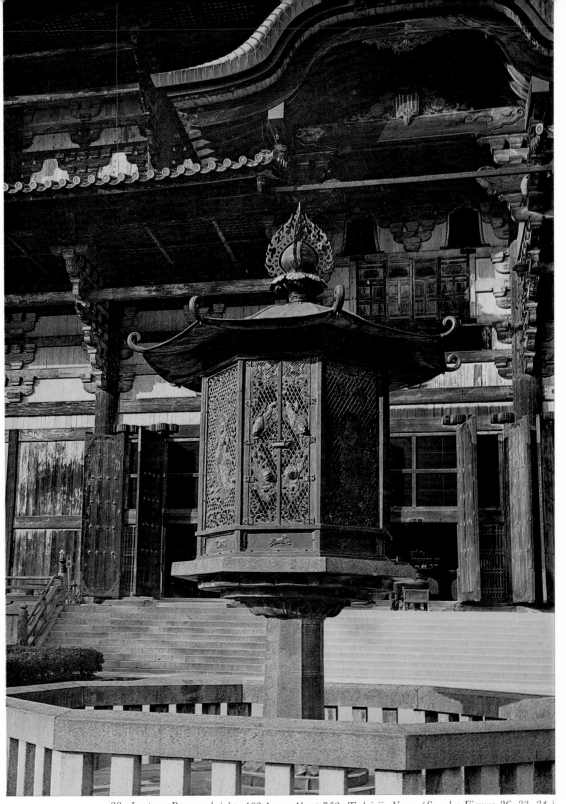

23. Lantern. Bronze; height, 462.1 cm. About 752. Todai-ji, Nara. (See also Figures 26, 33, 34.)

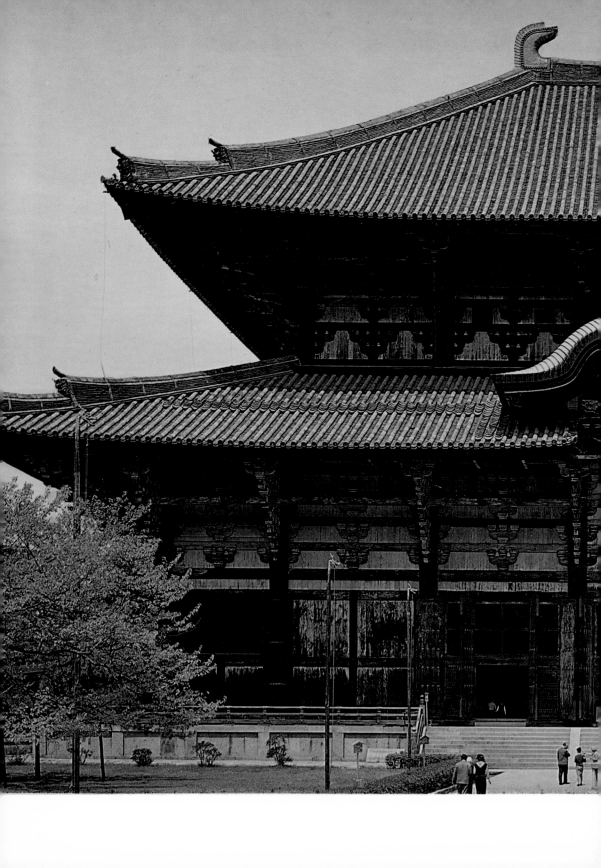

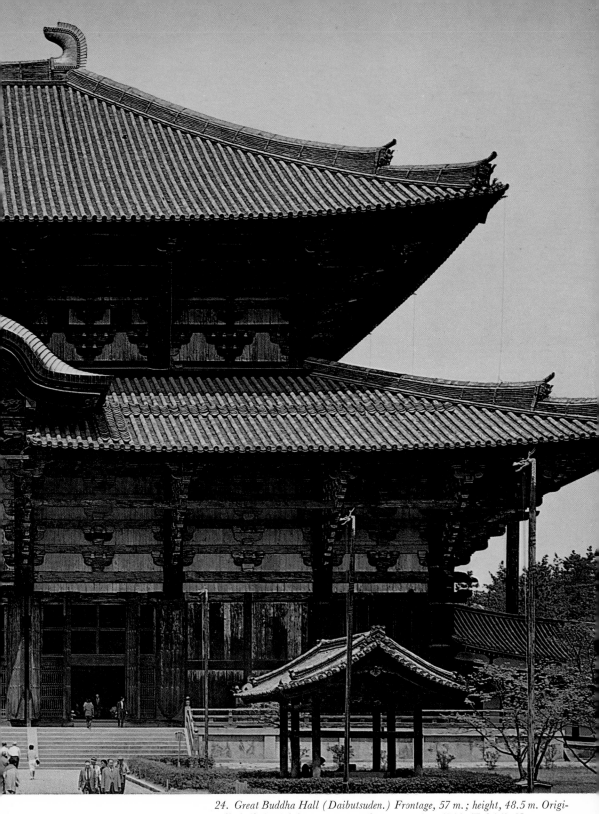

24. Great Buddha Hall (Daibutsuden.) Frontage, 57 m.; height, 48.5 m. Originally built in eighth century; second reconstruction, 1708. Todai-ji, Nara.

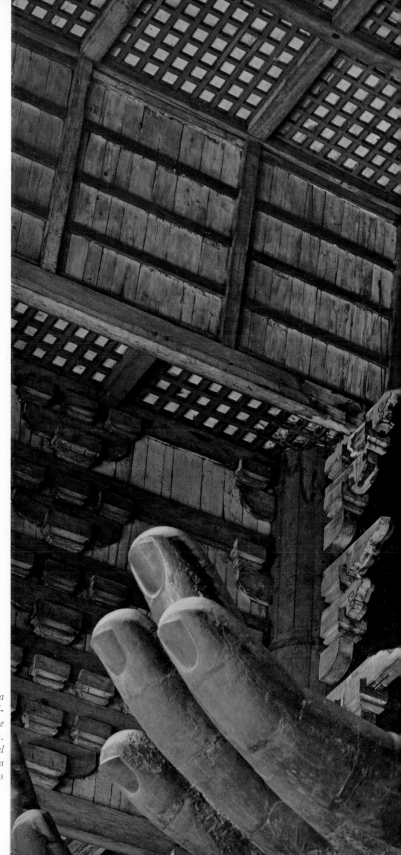

25. *Birushana Butsu (the Buddha Vairocana), known as the Great Buddha of Nara. Bronze; height of entire statue (see Figure 32), 16.19 m. Originally completed in 757; restored in present form in 1692. Great Buddha Hall, Todai-ji, Nara. (See also Figures 29–31, 110.)*

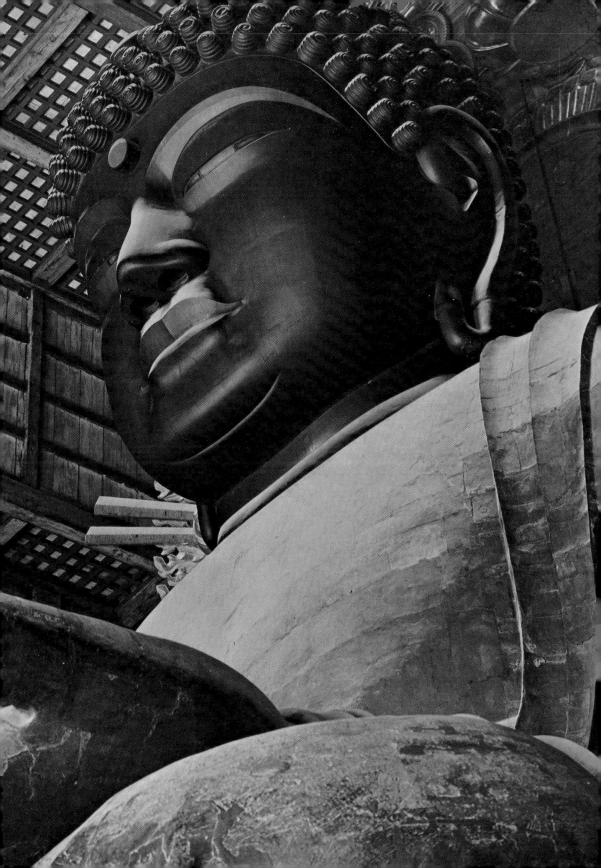

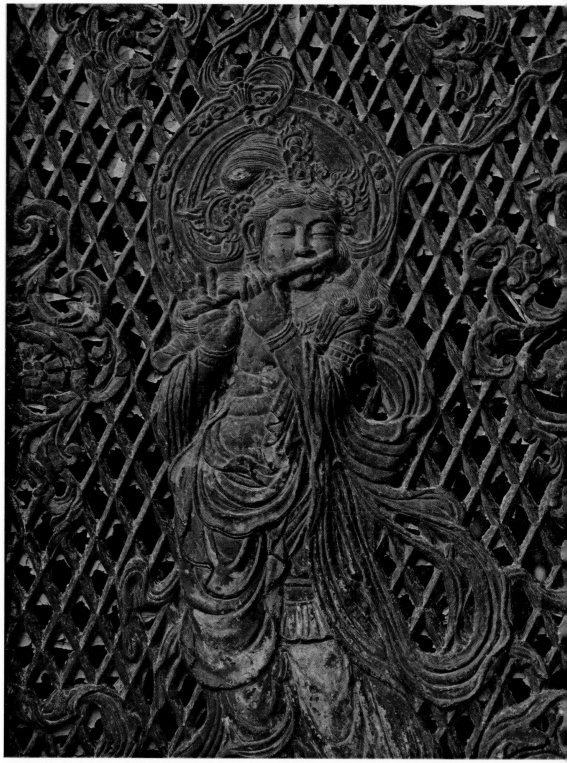

26. *Detail of lantern, showing a Bodhisattva. Bronze. About 752. Todai-ji, Nara. (See also Figures 23, 33, 34.)*

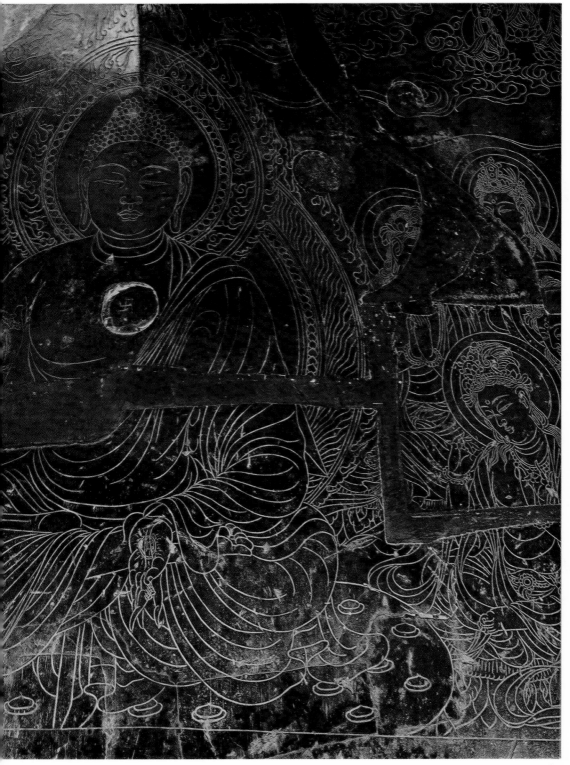

Engraving of Shaka Nyorai on lotus pedestal of the Great Buddha. Bronze. 757. Great Buddha Hall, Todai-ji, Nara. (See also res 35, 36, 114, and Foldout 1.)

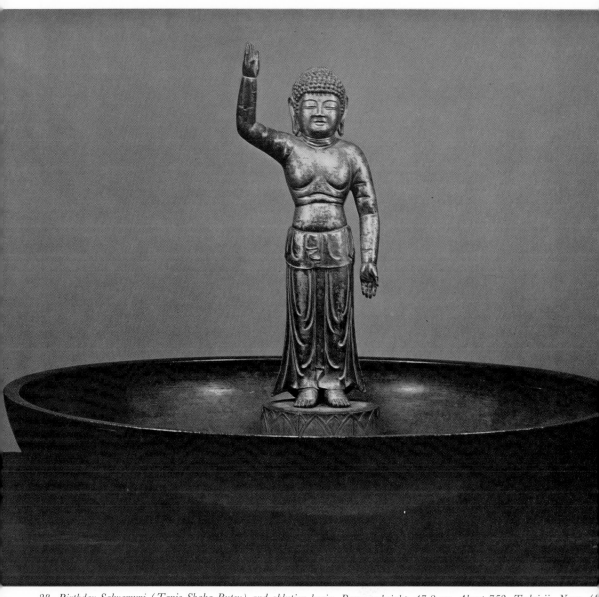

28. Birthday Sakyamuni (Tanjo Shaka Butsu) and ablution basin. Bronze; height, 47.3 cm. About 752. Todai-ji, Nara. (Se̦e also Figures 41, 42, 125.)

CHAPTER THREE

———•———

The Great Buddha
and the Todai-ji

AN ORDER FROM THE EMPEROR The rescript in which the emperor Shomu ordered the construction of the Great Buddha, or Daibutsu, was issued in the autumn of 743. As an expression of the emperor's piety and determination, it is a document of considerable interest. It begins by noting that although Japan is enjoying the blessings of Buddhism, it has not yet been completely permeated by the Buddhist law. Therefore, says the emperor, "we shall build and dedicate a gilt-bronze statue of the Buddha Vairocana." He then exhorts the people as follows: "Melt any and all bronze available in the country, grade the hills in order to build a temple hall, carry the message to all corners of the Buddhist universe, and gather information to add to my knowledge. Let us benefit from one another, and let us all achieve enlightenment."

The emperor continues by pointing out that "the project may not seem to be a difficult one, but to achieve the required state of mind is difficult indeed." He goes on to state his fear that "merely troubling a good many people might result in failure to achieve awareness or in arousing complaints and slanders—a degeneration into an awful sin." Therefore, he says, "those who are learned should each make the most sincere effort to invite blessings by worshiping the Buddha Vairocana three times a day without fail and should each remind himself to make a statue of the Buddha of his own."

The rescript concludes: "If someone wants to help build the statue by bringing a bundle of grass or a handful of soil, allow him to do so. The heads of the provinces and counties must not punish the peasants for doing so, nor must they discourage them from doing so. Rather, proclaim this statement everywhere, near and far, and let my thought permeate."

THE CONSTRUCTION OF THE GREAT BUDDHA When it was announced that the site of the colossal statue of Vairocana was to be Nara and not Shigaraki, some of the basic framework for the construction project was already in place. It therefore had to be dismantled and reassembled at the new site. Work there got under way quickly, and by August of 745 the core of the statue was complete. The emperor Shomu and a glittering suite of officials and courtiers made a pilgrimage to the nearby temple Kinsho-ji to offer lights to Vairocana in celebration of the occasion.

The casting of the Great Buddha began early in the autumn of 747 and, running through three processes, was largely complete by midautumn of

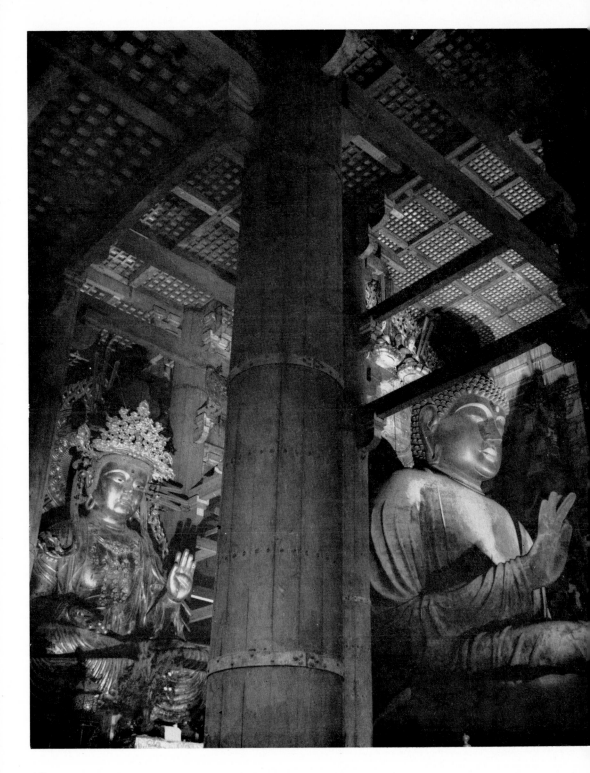

29. *View of inner sanctuary of Great Buddha Hall, Todai-ji, Nara. At right: Birushana Butsu (the Buddha Vairocana), known as the Great Buddha of Nara. Bronze; height, 16.19 m. Originally completed in 757; restored in present form in 1692. (See also Figures 25, 30–32, 110.)*

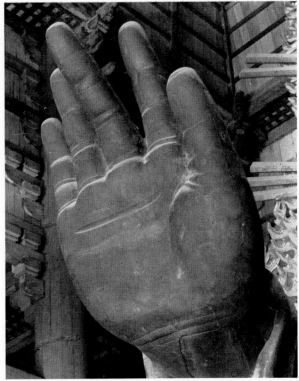

30. *Right hand of the Great Buddha of Nara. Bronze. Restoration of 1692. Great Buddha Hall, Todai-ji, Nara. (See also Figures 25, 29, 32, 110.)*

749. In December of that year, casting of the curls to adorn the Buddha's head (Fig. 31) was begun. The total of 966 of these curls took until June 751 to complete. Polishing of the head and trunk of the statue was no doubt being carried out during this period, and gilding began in mid-March of 752. This work was still not entirely accomplished when the dedication ceremonies were held on April 9 of the same year in the presence of the now retired emperor Shomu, his consort the empress Komyo, and the regnant empress Koken.

Although the statue itself had been completed, work on the project was still not over. In 757, engravers began to make the carvings of the Lotus Treasure World on the petals of the lotus pedestal, and from 763 to 771 work proceeded on the enormous aureole behind the statue.

The names of some of the leading artists and artisans engaged in the design and construction of the Great Buddha have been preserved. The master Buddhist sculptor was a man named Kuninaka no Muraji Kimimaro, and the master bronze-casters were Takechi no Muraji Okuni, Takechi no Muraji Mamaro, and Kakinomoto no Odama. We also know that the carpenters included Inabe no Momoyo and Masuda no Nawate. But these men can have been only the smallest part of the overall work force provided by the Bureau for the Construction of the Todai-ji. This organization necessarily called on the talents and the energies of an immense number of people.

When the organization in charge of the work on the temple was renamed the Bureau for the Construction of the Todai-ji, its structure became more

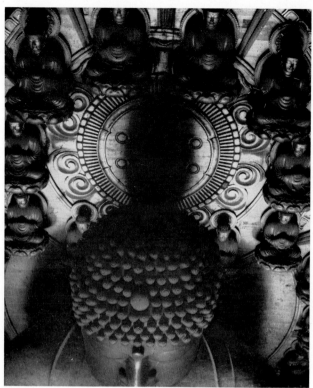

31. *Head of the Great Buddha of Nara, showing stylized curls. Bronze. Restoration of 1692. Great Buddha Hall, Todai-ji, Nara. (See also Figures 25, 32.)*

32. *Birushana Butsu (the Buddha Vairocana), known as the Great Buddha of Nara Bronze; height, 16.19 m. Originally completed in 757; restored in present form in 1692 Great Buddha Hall, Todai-ji, Nara. (See also Figures 25, 29–31, 110.)*

sophisticated, and its complement of manpower grew larger. Documents that have survived to the present offer detailed information on this structure. For instance, it is possible to know with certainty that the leaders of individual departments were people with court ranks and that the number of workers assigned to them varied with conditions and with the work in hand at the moment. By 759 the bureau had reached that scale at which it employed 8,000 workers and 200 supervisors under whom were department chiefs responsible for workers in the following fields: Buddhist sculpture, painting of Buddhist pictures, bronzework, ironwork, woodwork, lacquer making, tilemaking, gilding, and pottery making. The ordinary laborers were by and large corvée forces under severe pen-

alties for absconding. But the working conditions in the various departments were probably not unlike those of a well-run modern factory. Efficiency and productivity were prized. Consequently, although the supervisors and department heads may have enjoyed more luxurious fare, the common workers received large portions of wholesome food.

National finances were seriously disrupted by the project. As a result, when gold was discovered in Mutsu Province (the modern Aomori Prefecture) in 749, the emperor was so surprised and delighted that he made a special trip to the Todai-ji, accompanied by the empress, the crown princess, and high-ranking court officials, to announce the event to the still incomplete statue. In July of that

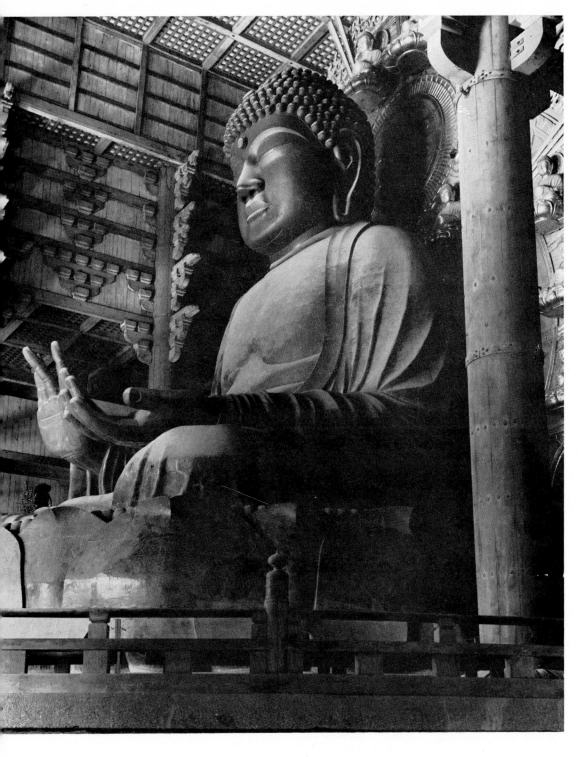

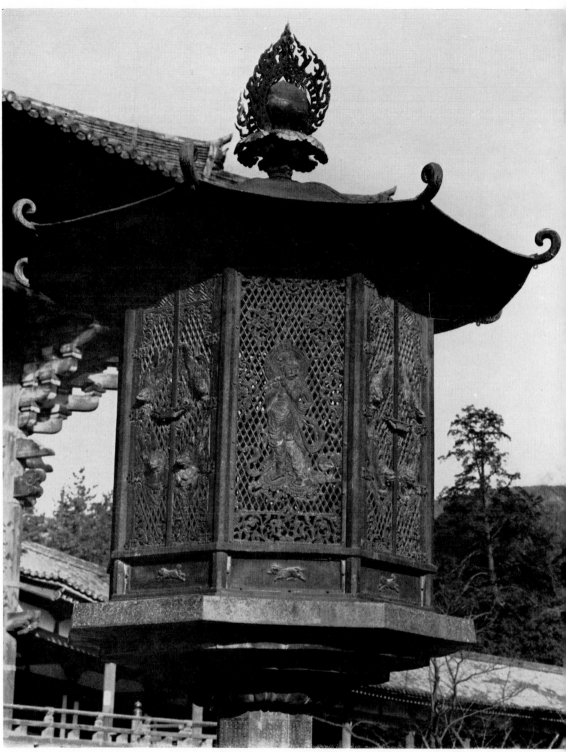

33. Lantern. Bronze; total height (see Figure 23), 462.1 cm. About 752. Todai-ji, Nara. (See also Figures 26, 34.)

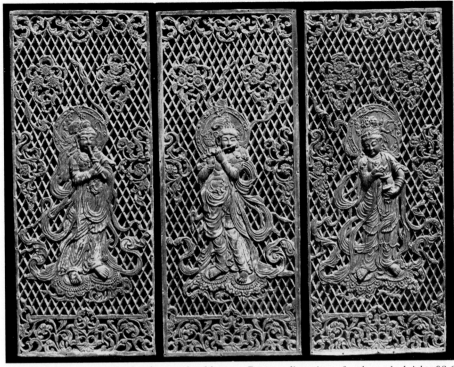

34. *Bodhisattvas on light-chamber panels of lantern. Bronze; dimensions of each panel: height, 93.6 cm.; width, 44 cm. About 752. Todai-ji, Nara. (See also Figures 23, 26, 33.)*

ear, weakened by illness, Shomu abdicated the throne in favor of his daughter, who then became the empress Koken.

In December of the same year, although the finishing touches had not yet been put to the statue, the retired emperor, his wife, and his daughter the empress, in the presence of five thousand priests, held ceremonies to celebrate the completion of the casting. As we have noted before, the dedication, or eye-opening, ceremony was not held until the spring of 752. (The term "eye opening" means the painting in of the pupils in the eyes of the statue.) It is recorded that never since the coming of Buddhism to Japan had such a magnificent ceremony been held. More than a decade was required to complete the statue, and forty years had to pass before the entire temple was finished.

THE TODAI-JI AND ITS BUILDINGS

The immense compound of the Todai-ji (Fig. 10) was bounded on the south and the west by walls. Since the north and the east sides were on the lower slopes of hills, no walls were built there. The west wall was pierced by three gates. In the south wall, on the main north-south axis of the temple, was the South Main Gate, or Nandaimon. Although the major buildings of most ancient temples were compactly placed within a single compound, the size of the Todai-ji made it impractical to follow this custom. Moreover, the nature and the functions of the Todai-ji made monumentality desirable. Consequently, the temple was made up of several compounds. The two pagodas, one to the east and the other to the west of the main axis, were surrounded by their own

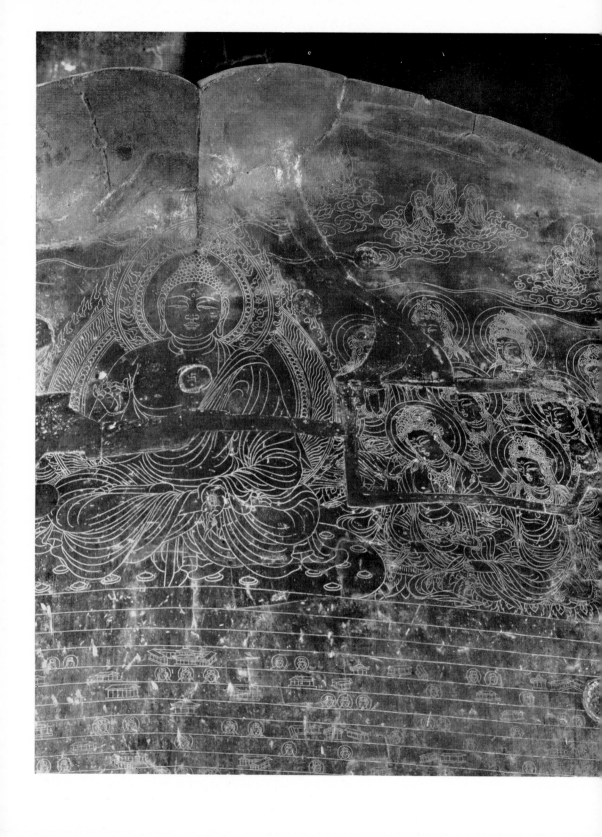

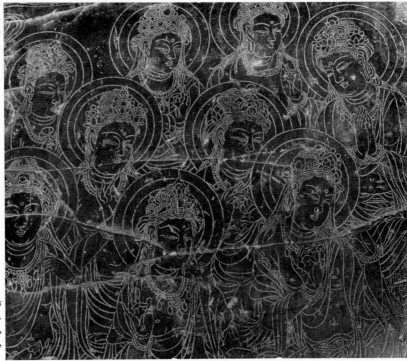

35. Shaka Nyorai and Bodhisattvas engraved on lotus pedestal of the Great Buddha. Bronze. 757. Great Buddha Hall, Todai-ji, Nara. (See also Figures 27, 36, 114, and Foldout 1.)

36. Bodhisattvas engraved on lotus pedestal of the Great Buddha. Bronze. 757. Great Buddha Hall, Todai-ji, Nara. (See also Figures 27, 35, 114, and Foldout 1.)

roofed corridors furnished with gates. Beyond the Inner Gate, or Chumon, was the compound of the Main Hall, or Great Buddha Hall (Daibutsuden), also surrounded by its own roofed corridors.

The Great Buddha Hall was 86 meters wide and 50 meters deep. The seven-storied pagodas, each standing in its own compound, were 100 meters tall. The Lecture Hall was located north of the Great Buddha Hall, and the Monks' Quarters surrounded it on the north, east, and west. To the east of this group of buildings was the Refectory.

VICISSITUDES OF THE GREAT BUDDHA

History has dealt cruelly with both the Todai-ji and the Great Buddha. Few of the eighth-century structures of the temple exist today, and the present statue of the Great Buddha tells very little about the nature of the original. In 1180, at the outset of the long war between the Taira and the Minamoto clans for control of the nation, Taira Shigehira and his forces set fire to the Todai-ji. In the ensuing conflagration, which devastated the greater part of the temple, the head, the hands, and part of the trunk and the lotus pedestal of the statue were destroyed. The damage to both the temple and the statue was repaired through the efforts of the famous priest Chogen, who conducted a fund-raising campaign for the purpose.

Another conflagration occurred in 1567, when Matsunaga Hisahide, a powerful vassal of the Ashikaga shogun and a leader in the tumultuous events of his time, set fire to the Todai-ji. This time the head of the Great Buddha was destroyed. The damage was soon repaired, but it was done in makeshift fashion by means of a wooden under-

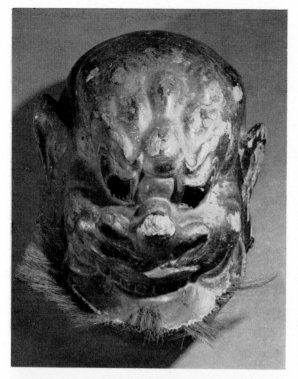

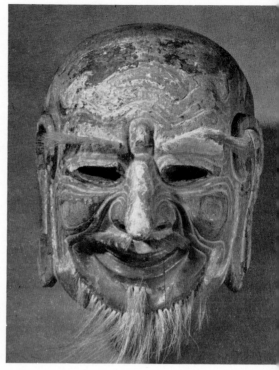

37 (above, left). Gigaku mask. Painted wood; height, 39.4 cm. 751. Todai-ji, Nara.

38 (above, right). Gigaku mask. Painted wood; height, 27. cm. 751. Todai-ji, Nara.

39 (left). Gigaku mask. Painted wood; height, 39.4 cm. About 752. Todai-ji, Nara.

40 (opposite page). Gigaku mask. Dry lacquer with colors; height, 32.3 cm. 752. Todai-ji, Nara.

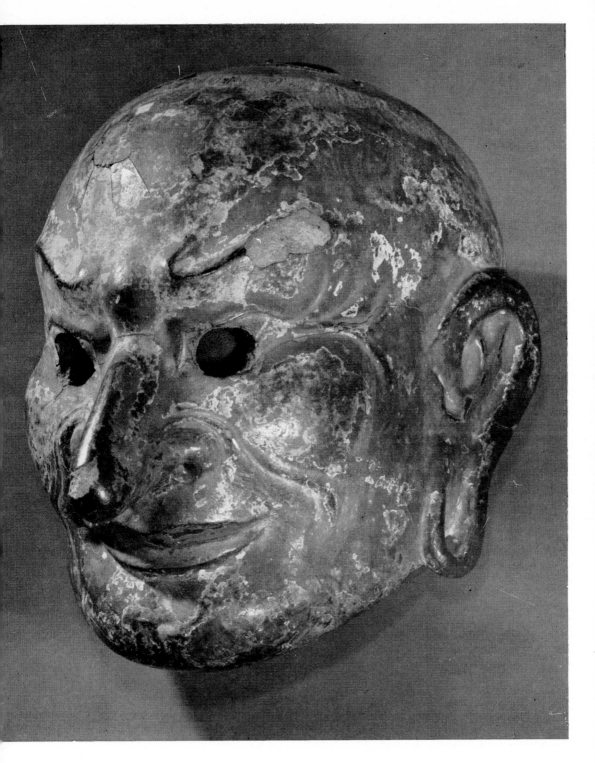

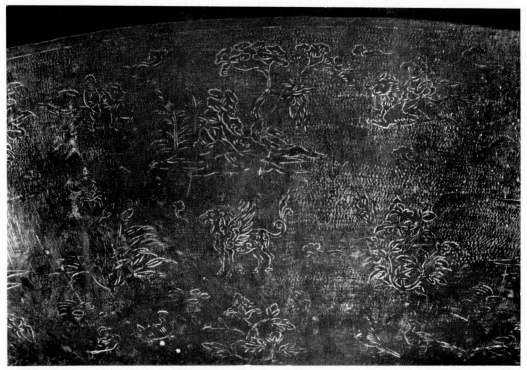

41. Engravings on ablution basin of Birthday Sakyamuni. Bronze. About 752. Todai-ji, Nara. (See also Figures 28, 125.)

structure covered with thin sheets of bronze. Finally, in 1692, under the direction of Ryushoin Kokei, the statue was restored to the condition in which it now exists (Figs. 25, 29–32, 110). Although little of the original remains, some aspects of the present figure suggest the mood and dignity of the Nara-period work. The statue conveys a powerful feeling of magnanimity and great strength.

WORKS RELATED TO THE ORIGINAL GREAT BUDDHA Some parts of the lotus petals survive from the original pedestal of the Great Buddha to give an indication of what the first statue must have been like. These petals are engraved with representations of the Lotus Treasure World and display many figures of Buddhas and Bodhisattvas (Figs. 27, 35, 36, 114; Foldout 1). Although the petals

were made somewhat later than the statue, the Buddhas shown on them are probably very much like the first Great Buddha in the brightness and expansiveness of their mood.

The large bronze lantern in front of the Great Buddha Hall at the Todai-ji is ornamented with low-relief figures of Bodhisattvas playing musical instruments (Figs. 23, 26, 33, 34). The maturity of the sculptural technique, the richness of the portrayal, and the serene, blissful look of the Bodhisattvas themselves give us some idea of what the Great Buddha may have been like. The lantern, which seems to recall the splendor and joy of the achievement represented by the Great Buddha, was probably made not long after the dedication ceremonies of 752. It therefore reveals much about the nature of fully matured Nara-period art.

Still other evidence of the high quality of Nara

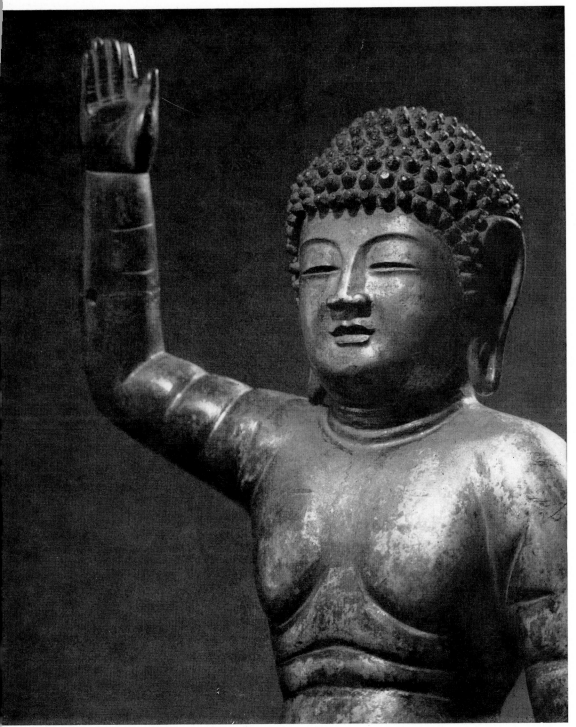

42. *Birthday Sakyamuni (Tanjo Shaka Butsu). Bronze; height of entire statue (see Figure 28), 47.3 cm. About 752. Todai-ji,*
Nara.

43. Left hand of Taishaku Ten. Dry lacquer with colors; height of entire statue (see Figure 134), 404.6 cm. 757–64. Sangatsudo, Todai-ji, Nara. (See also Figure 68.)

44. Mo (ancient-style skirt) of Fukuken-jaku Kannon. Dry lacquer with colors; height of entire statue (see Figure 48), 360.6 cm. 746. Sangatsudo, Todai-ji, Nara.

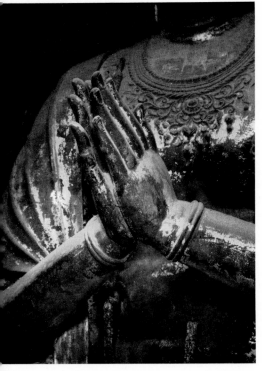

46. Hands of Fukukenjaku Kannon. Dry lacquer with colors; height of entire statue (see Figure 48), 360.6 cm. 746. Sangatsudo, Todai-ji, Nara.

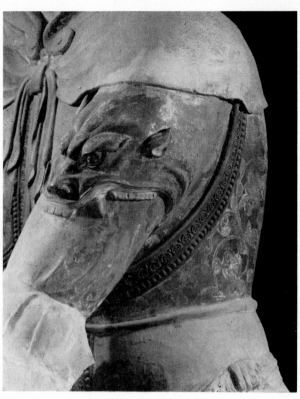

47. Shoulder of Zocho Ten, one of the Four Celestial Guardians. Dry lacquer with colors; height of entire statue (see Figure 56), 363 cm. 757–64. Sangatsudo, Todai-ji, Nara.

48. Fukukenjaku Kannon with Gakko Bosatsu (left) and Nikko Bosatsu (right). Fukuken jaku Kannon: dry lacquer with colors; height 360.6 cm.; 746. Gakko Bosatsu and Nikko Bosatsu: painted clay; heights, 224.4 an 226.1 cm., respectively; 742–46. Sangatsudo Todai-ji, Nara. (See also Figures 5, 15, 49 51, 108, 129, 130.)

sculpture is to be found in the so-called Birthday Sakyamuni (Tanjo Shaka Butsu; Figs. 28, 42). This plump and childishly charming figure is used in ceremonies honoring the birthday of the Buddha on April 8. In its fullness and richness, the figure sheds additional light on what must have been the sculptural approach in creating the first Todai-ji Daibutsu.

We have noted that the dedication ceremonies for the Great Buddha were a splendid affair involving a full array of the court and the high clergy. For an occasion of such gorgeousness, performances of the masked dance-drama called Gigaku would have been indispensable. It is known that such performances were given and that a large number of masks were made for the performers. More than 160 of these masks are now preserved in

the imperial treasure repository Shoso-in, in Nara A much smaller number (only about 10) are kep in the Todai-ji treasury (Figs. 37–40, 64, 65).

Gigaku, no longer extant today, originated i China and was introduced into Japan in 612 by man named Mimashi, who came from the Korea kingdom of Paekche. It called for a variety o masks in highly fanciful forms. Unlike the late Noh masks, which cover only the face, the mask for Gigaku covered the entire head. It is interesting to note that the expressions of the Todai-ji mask have much in common with those on the faces o the Four Celestial Kings kept in the Kaidan-i (Figs. 17, 18, 21, 22, 60, 61, 138–41). The Todai-j and the Shoso-in Gigaku masks are the oldest the atrical masks in the world. Interestingly, many o them bear the carvers' names in ink.

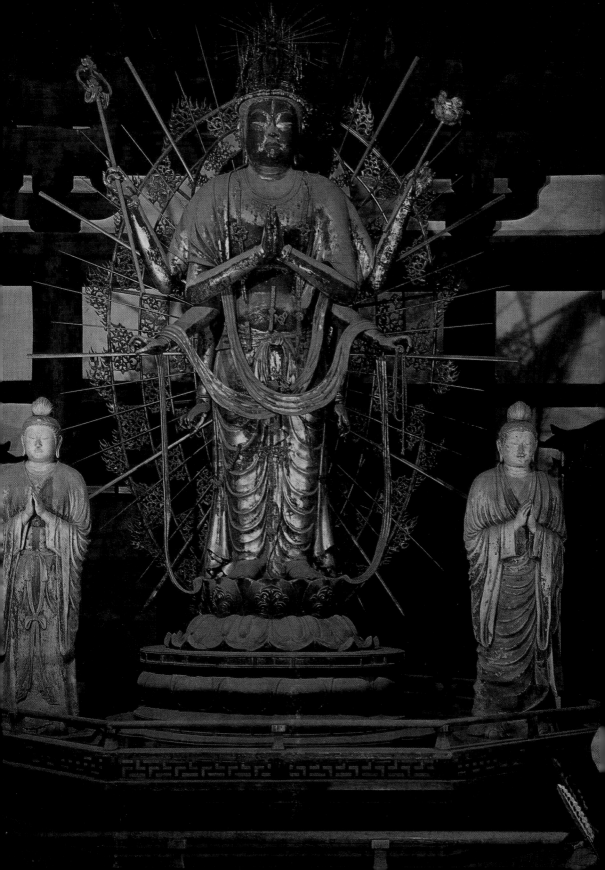

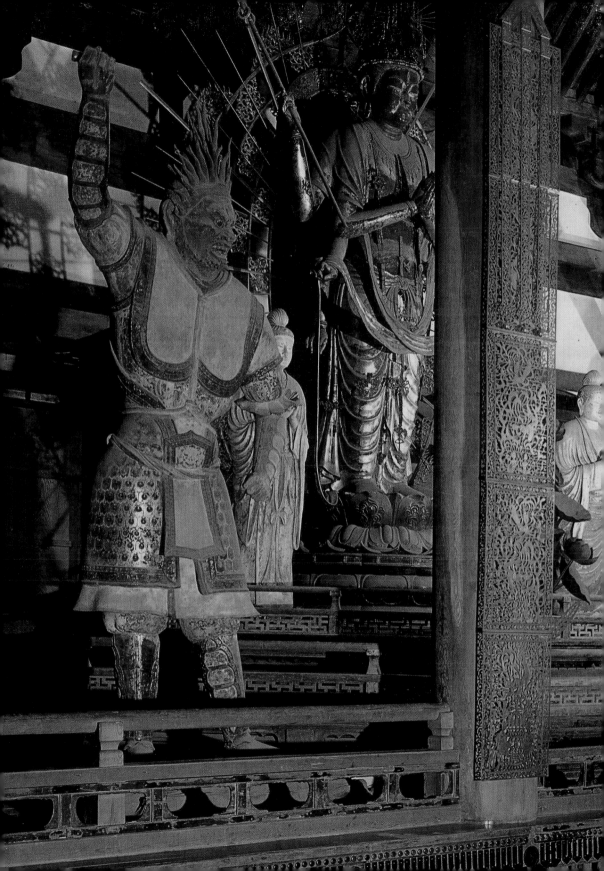

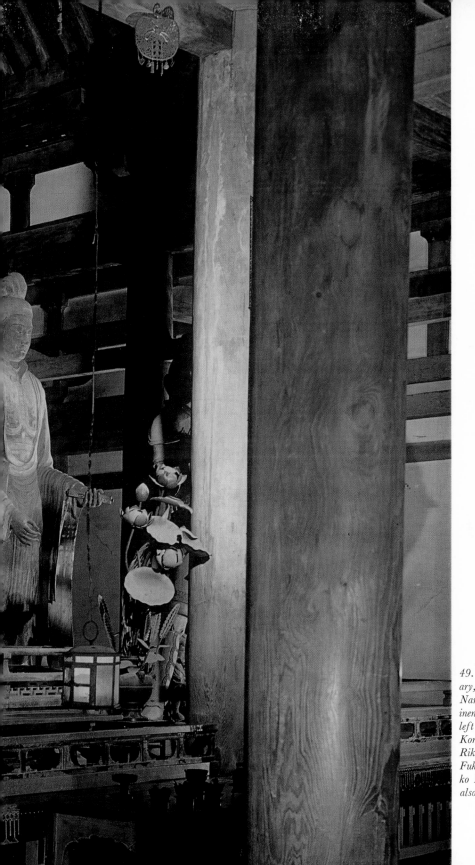

49. View of inner sanctuary, Sangatsudo, Todai-ji, Nara. Eighth century. Prominently visible statues, from left to right: Misshaku Kongo (one of the Kongo Rikishi), Gakko Bosatsu, Fukukenjaku Kannon, Nikko Bosatsu, Bon Ten. (See also Figure 70.)

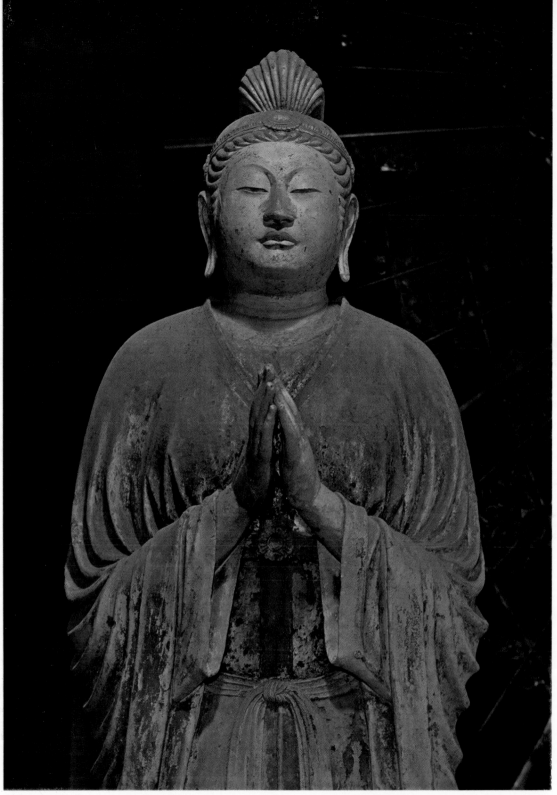

50. *Gakko Bosatsu. Painted clay ; height of entire statue (see Figure 130), 224.4 cm. 742–46. Sangatsudo, Todai-ji, Nara. (See also Figures 15, 45, 48, 108.)*

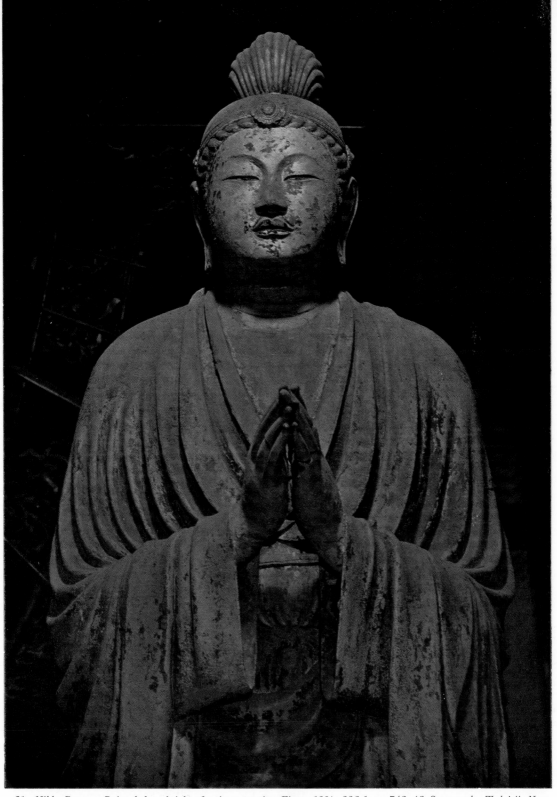

51. *Nikko Bosatsu. Painted clay; height of entire statue (see Figure 129), 226.1 cm. 742–46. Sangatsudo, Todai-ji, Nara. (See also Figures 15, 16, 48.)*

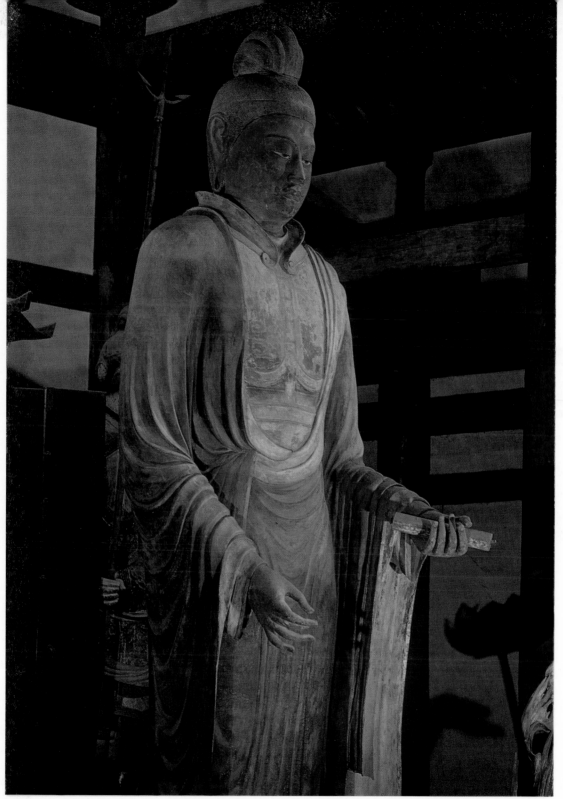

52. *Bon Ten. Dry lacquer with colors; height of entire statue (see Figure 135), 402.8 cm. 757–64. Sangatsudo, Todai-ji, Nara.*

53. *Kichijo Ten. Painted clay; height of entire statue (see Figure 131), 218.8 cm. 772. Sangatsudo, Todai-ji, Nara.* ▷

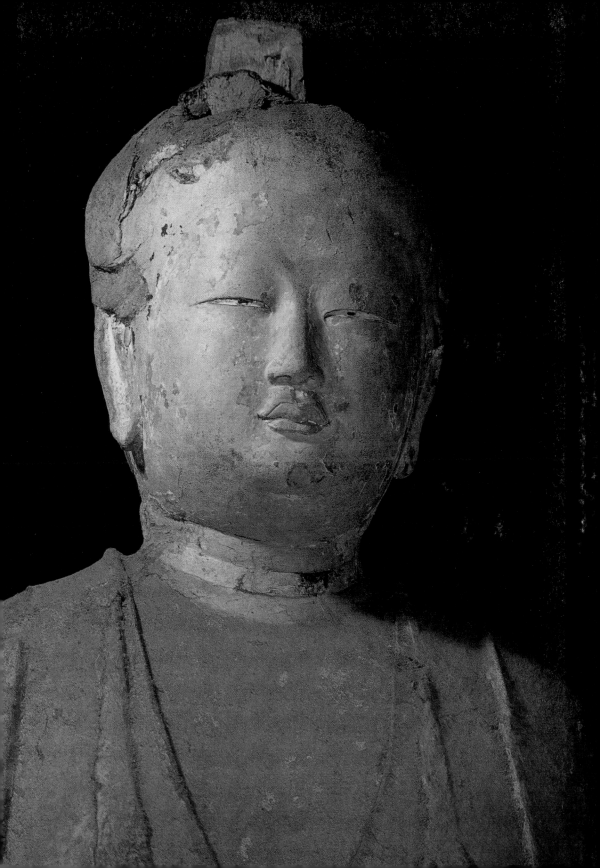

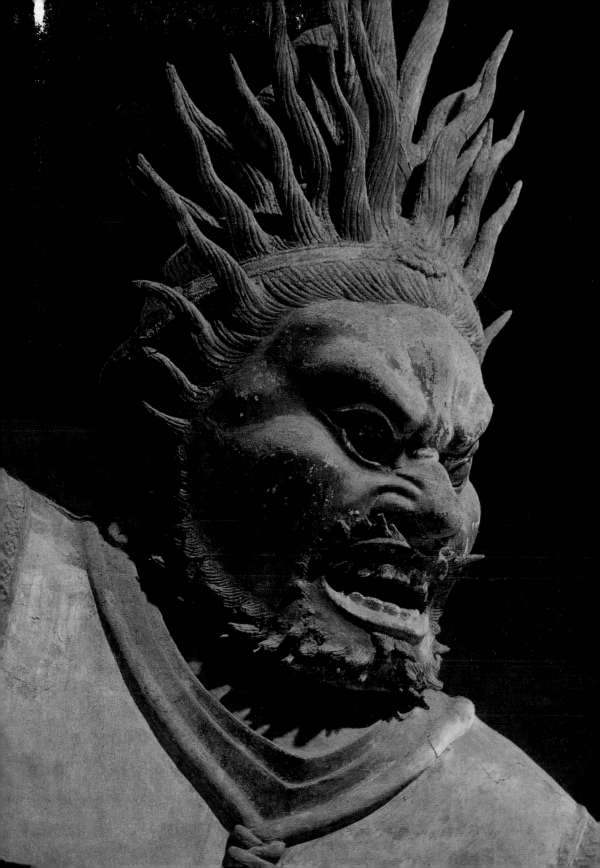

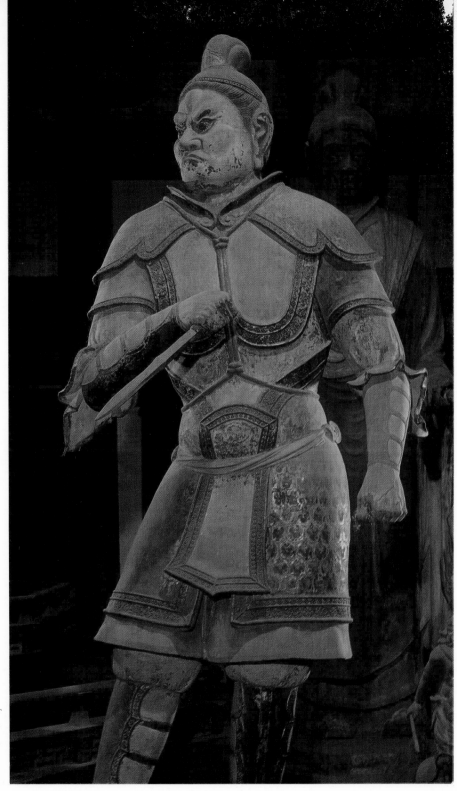

*Misshaku Kongo, one
~~of~~ the Kongo Rikishi. Dry
~~lac~~quer with colors; height
~~of~~ entire statue (see Figure
~~68~~), 326 cm. 757–64. San-
~~ge~~sudo, Todai-ji, Nara.
~~(See~~ also Figure 67.)*

*~~68.~~ Naraen Kongo, one of
~~the~~ Kongo Rikishi. Dry
~~lac~~quer with colors; height,
~~32~~2 cm. 757–64. San-
~~ge~~sudo, Todai-ji, Nara.
~~(See~~ also Figure 69.)*

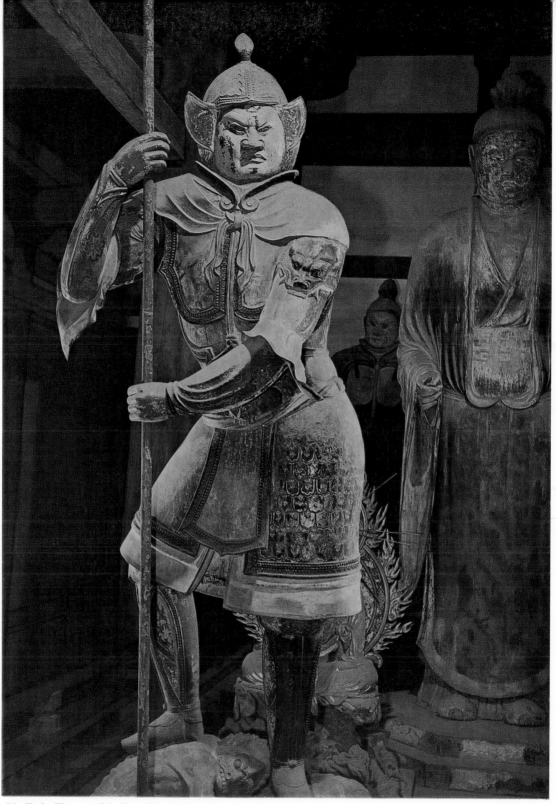

56. *Zocho Ten, one of the Four Celestial Guardians. Dry lacquer with colors; height, 363 cm. 757–64. Sangatsudo, Todai-ji, Nara. (See also Figures 47, 59, 63, 77, 161.)*

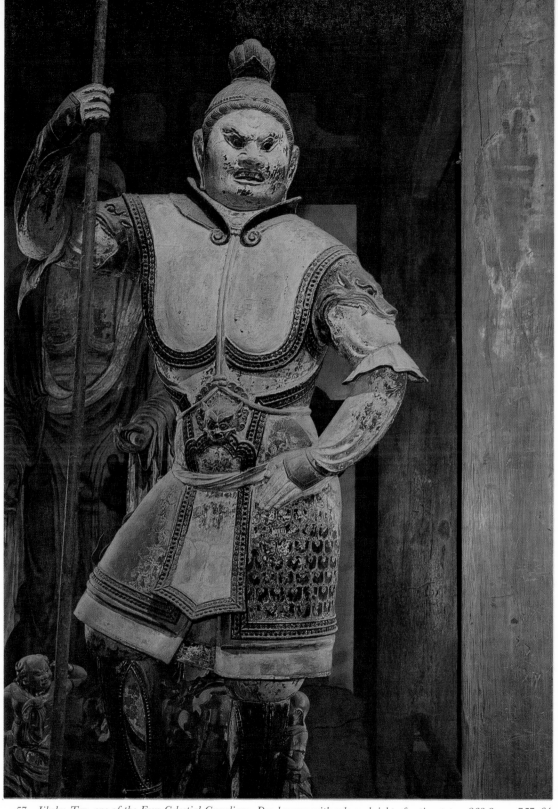

57. Jikoku Ten, one of the Four Celestial Guardians. Dry lacquer with colors; height of entire statue, 363.3 cm. 757–64.
Sangatsudo, Todai-ji, Nara.

58. Detail of Komoku Ten, one of the Four Celestial Guardians. Dry lacquer with colors; height of entire statue (see Figure 13) 327 cm. 757–64. Sangatsudo, Todai-ji, Nara. (See also Figure 160.)

Detail of Zocho Ten, one of the Four Celestial Guardians. Dry lacquer with colors; height of entire statue (see Figure 56), 363 757–64. Sangatsudo, Todai-ji, Nara. (See also Figures 47, 63, 77, 161.)

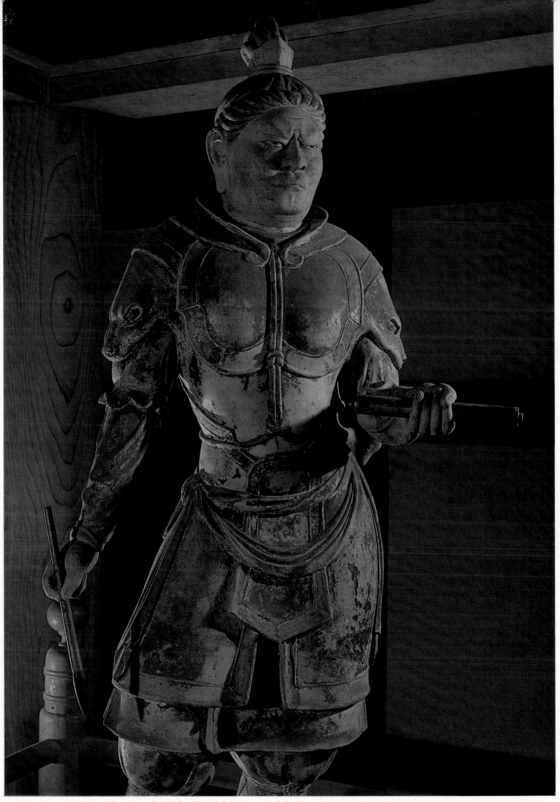

60, 61. *Komoku Ten (above) and Jikoku Ten (right), two of the Four Celestial Guardians. Painted clay; height of Komoku Ten, 163.5 cm; height of Jikoku Ten, 178.2 cm. 742–46. Kaidan-in, Todai-ji, Nara. (See also Figures 18, 22, 116, 139, 140.)*

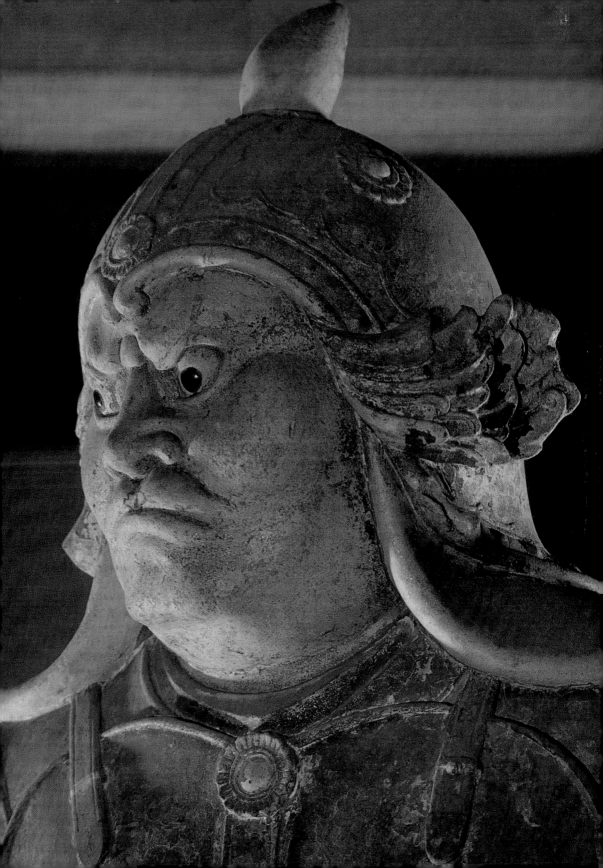

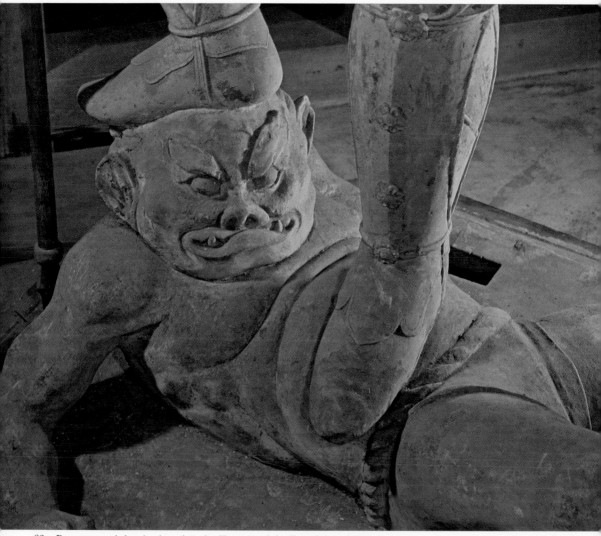

62. Demon trampled under feet of Zocho Ten, one of the Four Celestial Guardians.
Painted clay. 742–46. Kaidan-in, Todai-ji, Nara. (See also Figure 141.)

63. Demons trampled under feet of Zocho Ten, one of the Four Celestial Guardians.
Painted clay. 757–64. Sangatsudo, Todai-ji, Nara. (See also Figure 56.)

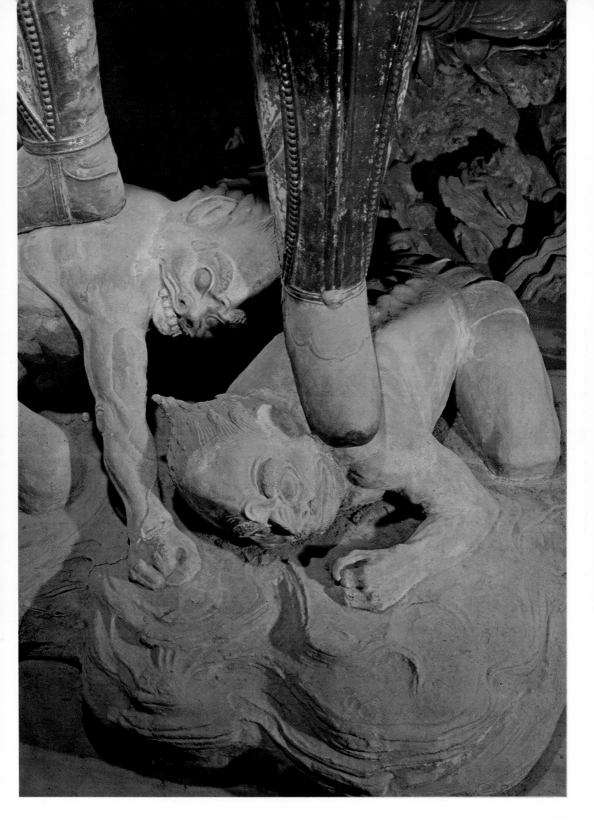

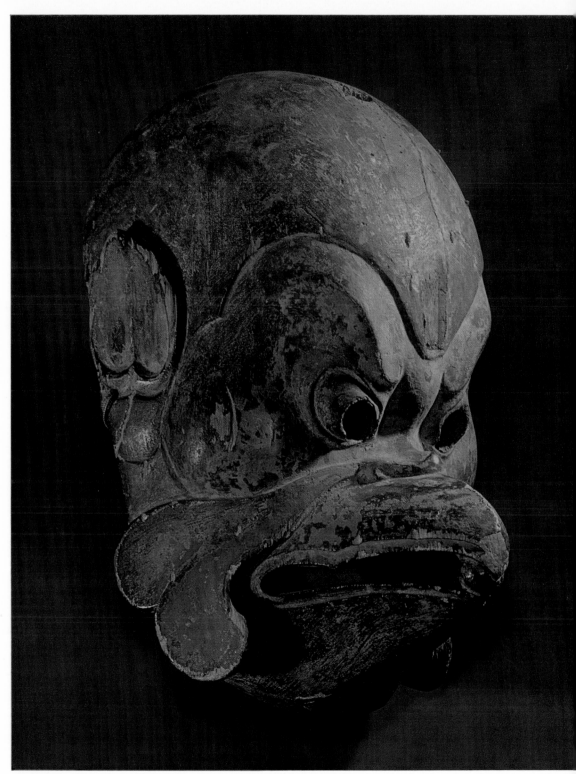

64. Gigaku mask. Painted wood; height, 33.3 cm. About 752. Todai-ji, Nara.

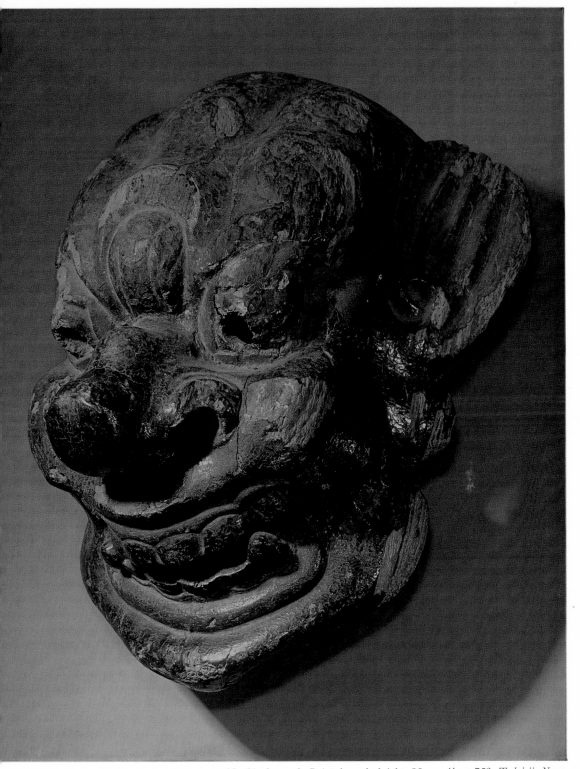

65. *Gigaku mask. Painted wood; height, 38 cm. About 752. Todai-ji, Nara.*

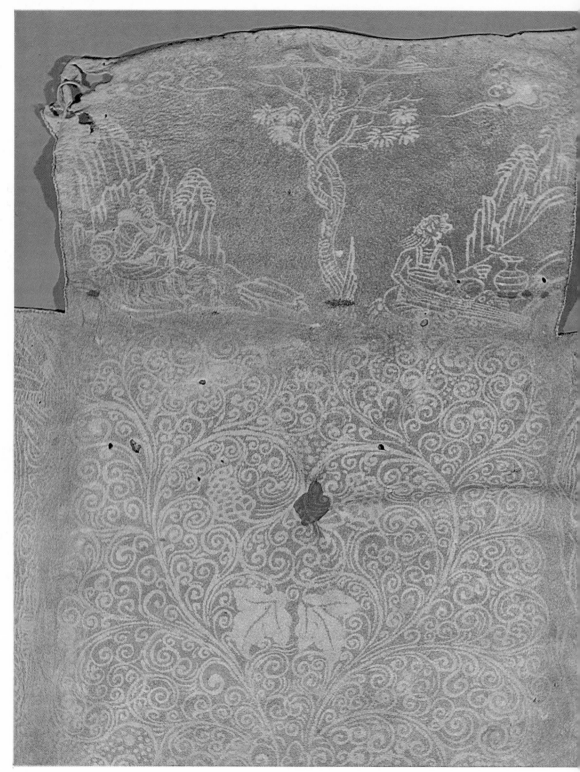

66. Pattern-dyed deerskin. Length, 76.5 cm.; width, 66 cm. Eighth century. Todai-ji, Nara.

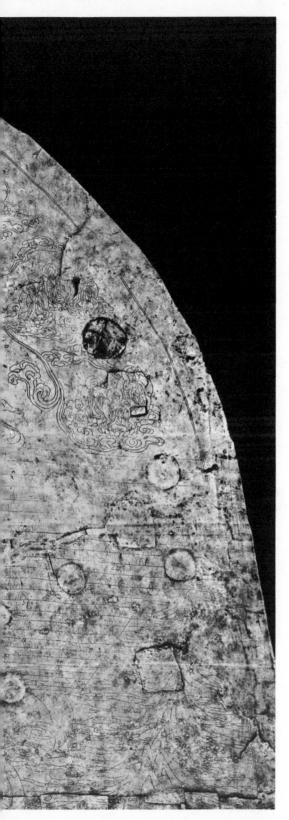

Foldout 1:
The Lotus Treasure World as Depicted on the Pedestal of the Great Buddha of Nara

According to the *Flower Wreath Sutra,* the throne of the Buddha Vairocana is a great lotus flower with a thousand petals. Each of these petals is a universe in which dwells a manifestation of the Buddha Sakyamuni (Shaka Nyorai) together with his attendant Bodhisattvas and myriads of other Buddhas. The line engravings on the petals of the bronze lotus that forms the pedestal of the Great Buddha of Nara picture this Lotus Treasure World, as it is called, and the photograph presented here shows a rubbing of one of the petals. Although time and recurrent calamities have effaced much of what the eighth-century artists of Nara portrayed on the Great Buddha's lotus throne, a number of the elements in the engravings are still reasonably distinct. The diagram below indicates the major features of the depiction.

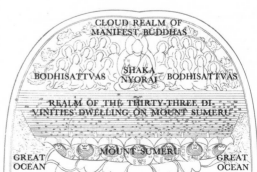

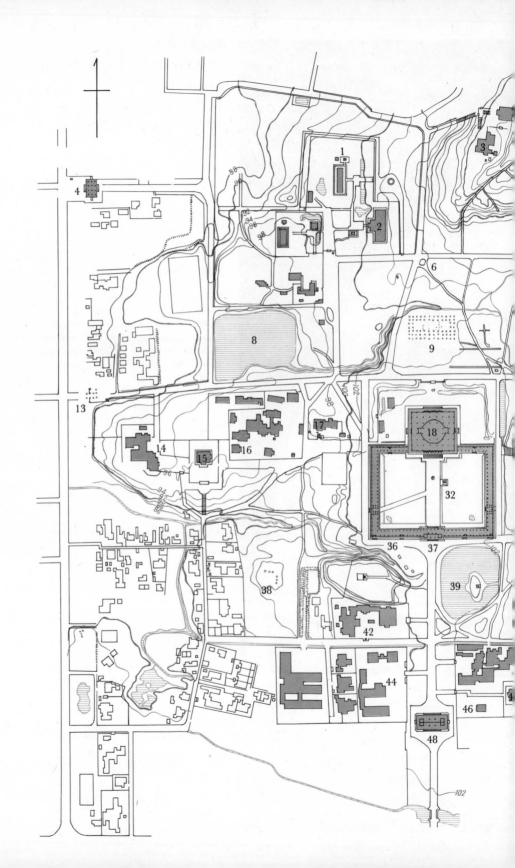

CHAPTER FOUR

Other Nara-Period Works at the Todai-ji

IN THIS CHAPTER I should like to discuss briefly a number of other sculptural works that were probably produced under the guidance of the Bureau for the Construction of the Todai-ji. They are of interest here because of what they reveal concerning Nara-period sculpture at this particular phase of its development.

THE SHAKA AND THE TAHO BUDDHAS IN THE KAIDAN-IN The bronze statuettes of Shaka Nyorai (Sakyamuni) and Taho Butsu (the Buddha Prabhutaratna) shown in Figures 73 and 74 are said to have originally stood in a Taho-to (Prabhutaratna pagoda) in the center of the ordination altar (kaidan) from which the Kaidan-in takes its name. Ordination ceremonies employing this altar were conducted by the great Chinese priest Chien Chen (in Japanese, Ganjin), who is said to have brought the two statuettes from T'ang China. It seems more likely, however, that they were made in Japan for the purpose of serving as the major objects of veneration in the Kaidan-in soon after its completion in 755.

The statues are not in their original condition. Because of damage apparently caused by fire, the metal surfaces have been roughened. Repairs seem to have been made at some time in their history,

and the gold inlay patterns decorating the garments of the two Buddhas are clearly later additions. The loss of the gold that probably once covered them gives the figures a slightly coarse appearance, but the generosity, boldness, and strength of their composition and their details are unmistakable indications of the T'ang style as interpreted in Japan. For this reason I feel certain that these statues must have been made during the years when Nara sculpture reached its highest level of achievement—probably not long after 756.

THE MANDORLA OF THE NIGATSUDO KANNON BOSATSU The main image of the Nigatsudo (Second-Month Hall), a statue of the Bodhisattva Kannon, is a hibutsu (secret Buddha) that is unavailable for examination or photography, but the engravings of Bodhisattvas on the front and back of the bronze mandorla of the statue give some idea of what the Kannon may look like. The mandorla was broken into a number of pieces in a fire at the Nigatsudo in 1667. Now stored in the Nara National Museum, it may be seen, although it has never been restored and is in badly fragmented condition (Figs. 75, 76). More interesting, however, than the hints the mandorla has to offer about the form of the Nigatsudo Kannon is the similarity

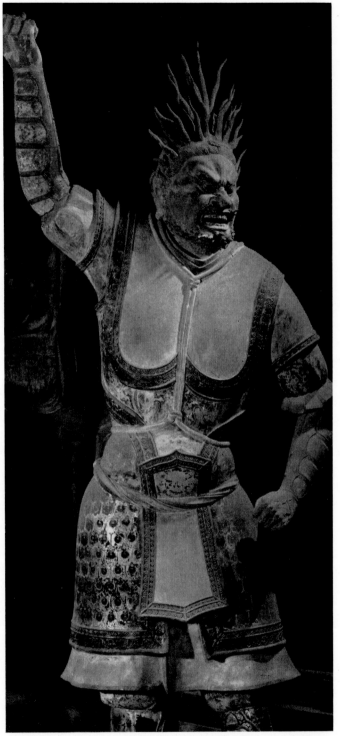

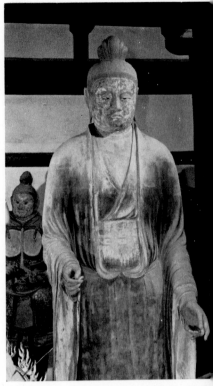

68. *Taishaku Ten. Dry lacquer with colors; height of entire statue (see Figure 134), 404.0 cm. 757–64. Sangatsudo, Todai-ji, Nara. (See also Figure 43.)*

67. *Misshaku Kongo, one of the Kongo Rikishi. Dry lacquer with colors; height of entire statue (see Figure 49), 326 cm. 757–64. Sangatsudo, Todai-ji, Nara. (See also Figure 54.)*

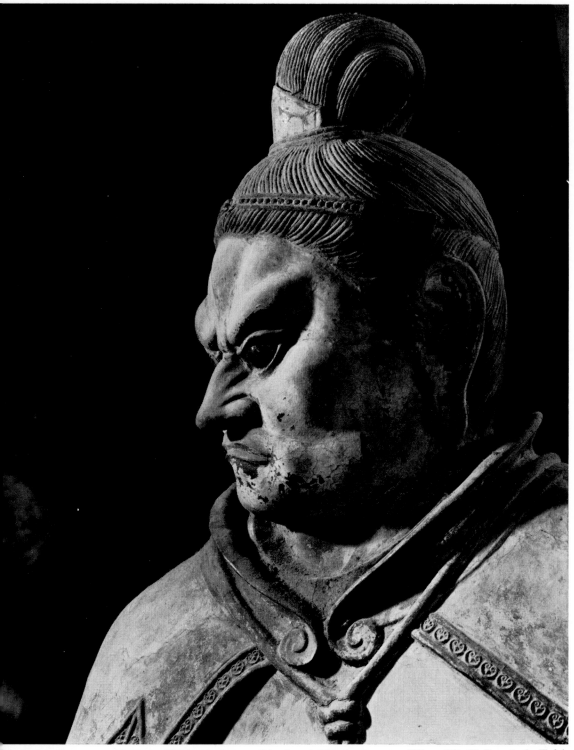

59. *Naraen Kongo, one of the Kongo Rikishi. Dry lacquer with colors; height of entire statue, 332 cm. 757–64. Sangatsudo, Todai-i, Nara. (See also Figure 55.)*

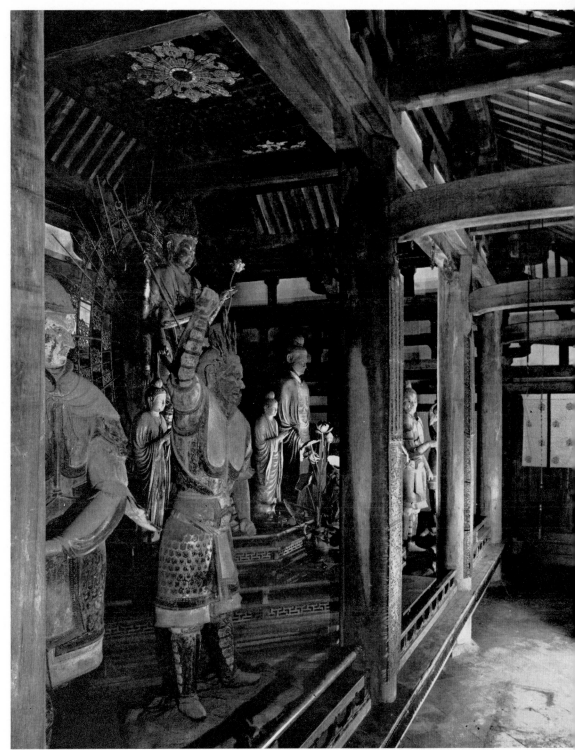

70. View of inner sanctuary, Sangatsudo, Todai-ji, Nara. Eighth century. (See also Figure 49.)

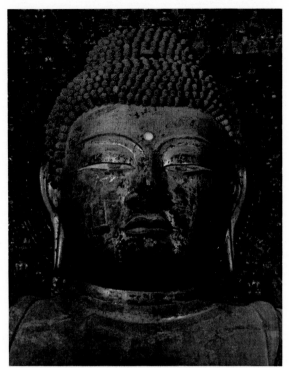

71. *Detail of screen panel picturing a Chinese lady under a tree. Ink and colors on paper; originally embellished with small feathers. Eighth century. Shoso-in, Todai-ji, Nara.*

72. *Head of Rushana (Birushana) Butsu (the Buddha Vairocana). Dry lacquer with colors; height of entire statue, 303 cm. 759. Golden Hall, Toshodai-ji, Nara.*

between the engraved figures on it and those on the surviving petals of the original Todai-ji Great Buddha lotus pedestal. In both cases the figures of the Bodhisattvas and the Buddhas are rich, full, and relaxed. Such representations were the ideal of the Nara sculptural style at its peak.

THE DRY-LACQUER STATUES IN THE SANGATSUDO

I have already mentioned the group of large dry-lacquer statues of Bon Ten, Taishaku Ten, the Four Celestial Guardians, and the Kongo Rikishi in the Sangatsudo, but I wish to call attention to them once again here because they have a place

among the works probably produced under the guidance of the Bureau for the Construction of the Todai-ji. Although these statues clearly belong to the mainstream of Nara-period sculpture, they already reveal a certain lack of tension and strength that makes it impossible to put them among works representing the style at its best. In terms of their somewhat vague yet magnanimous forms, they very closely resemble the statue of the Buddha Vairocana in the Golden Hall of the Nara temple Toshodai-ji (Fig. 72). Since this image was made in 759, it is quite likely that the dry-lacquer statues in the Sangatsudo were produced around the same time.

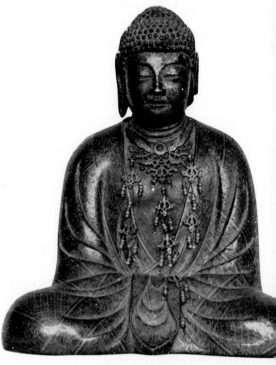

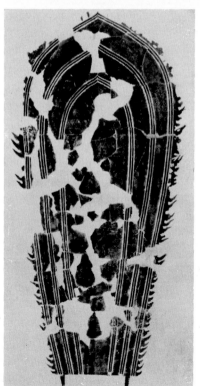

73 (above, left). Shaka Nyorai. Bronze; height, 24.9 cm. About 756. Kaidan-in, Todai-ji, Nara.

74 (above, right). Taho Butsu (the Buddha Prabhutaratna). Bronze; height, 24.9 cm. About 756. Kaidan-in, Todai-ji, Nara.

75 (left). Rubbing of bronze mandorla formerly behind Kannon Bosatsu in Nigatsudo (Second-Month Hall), Todai-ji, Nara. Height of mandorla: 231.8 cm. Eighth century. Nara National Museum.

76 (right). Bodhisattvas making offerings. Rubbing of detail of bronze mandorla formerly behind Kannon Bosatsu in Nigatsudo (Second-Month Hall), Todai-ji, Nara. Eighth century. Nara National Museum.

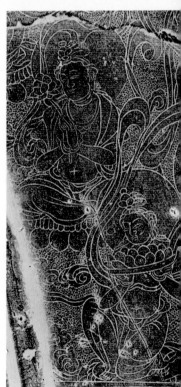

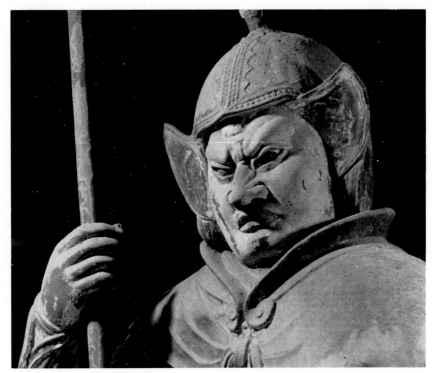

77. Zocho Ten, one of the Four Celestial Guardians. Dry lacquer with colors; height of entire statue (see Figure 56), 363 cm. 757–64. Sangatsudo, Todai-ji, Nara. (See also Figures 47, 59, 63, 161.)

THE KICHIJO TEN AND THE BENZAI TEN IN THE SANGATSUDO

The Kichijo Ten (Srimahadevi; also called Kissho Ten; Figs. 53, 131) and the Benzai Ten (Sarasvati; Figs. 132, 133) in the Sangatsudo are actually visitors there, for they were originally the main images of the Kichijodo, which stood in the hills east of the Sangatsudo. In 954 this building was destroyed by fire, and the badly damaged statues were moved to their present location. Ceremonial devotion to Kichijo Ten, goddess of beauty, wealth, and good fortune, was first recognized in Japan in 767, and the first worship services in her honor were held at the Todai-ji in

772. It is said that the statue now housed in the Sangatsudo is the one that was used in those services.

The full faces and figures of the Kichijo Ten and the Benzai Ten statues and the great skill with which they are executed prove that they belong to the true Nara-period tradition. The Kichijo Ten in particular, with its rounded face and small mouth, closely resembles the Chinese ladies depicted on a famous screen in the collection of imperial treasures stored in the Shoso-in repository of the Todai-ji (Fig. 71). It is an extremely impressive portrayal of femininity—indeed the most successful attempt of its kind in all Japanese sculpture.

CHAPTER FIVE

The Todai-ji School
of Sculpture

THE MANY SPLENDID works of Buddhist sculpture produced in connection with the Todai-ji can be considered as creations of what one may properly call the Todai-ji school. The products of this school include works of superlative quality representing the finest art of the Nara period. In the first part of the present chapter, for the sake of a more accurate understanding of the Todai-ji school, I should like to discuss some of the sculptural masterpieces of the early Nara period—the predecessors of the works created by that school.

THE HEAD OF YAKUSHI NYORAI FROM THE YAMADA-DERA The first of these early pieces that must be discussed is the head of Yakushi Nyorai (Bhaisajyaguru) now kept at the Kofuku-ji in Nara (Figs. 78, 96). Until fairly recently, this head, then believed to be the remains of the central figure of a Yakushi Triad that once stood in the East Golden Hall of the Kofuku-ji, was stored inside the pedestal of the main image in that building. The statue was reduced to its present sad state in a fire that destroyed the former East Golden Hall in 1411. Contrary to what had been thought, it was the main image in the Lecture Hall of the now vanished Yamada-dera at Asuka, in the southern part of the Nara Plain.

In 1180, at the same time that Taira Shigehira and his forces destroyed the Todai-ji, as we have already noted, they also set fire to the Kofuku-ji and burned it to the ground. The people engaged in restoring the East Golden Hall went to great pains to accomplish their task, and since the Yamada-dera, a branch temple of the Kofuku-ji, was in a state of decline at that time, they appropriated its Yakushi Triad for their own new building. The details of this event are related in the *Gyokuyo*, the diary of the regent Fujiwara Kanezane (1149–1207).

The Yakushi Triad had originally been made in supplication for the repose of the soul of Soga no Kurayamada no Ishikawamaro. In 678, people who honored the memory of this man, a political leader whose downfall had led to his suicide in 649, commissioned the casting of the triad. The work was completed seven years later, and dedication ceremonies were conducted in 685 on the anniversary of his death.

Although it is now impossible to know what the finished triad looked like, if we judge by this surviving head of Yakushi, we can assume that the work represented one of the earliest imports of the early T'ang style. The fullness of the face, the relaxed and bright expression, and the brimming vitality are a virtual summarization of this style.

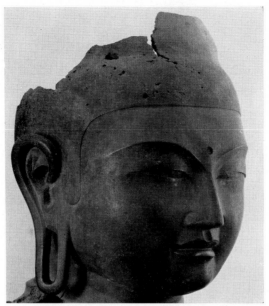

78. Head of Yakushi Nyorai. Bronze; height, 97.3 cm.
685. Relic of main image of former Yamada-dera, Sakurai,
Nara Prefecture. Kofuku-ji, Nara. (See also Figure 96.)

which contrasts sharply with the styles seen in Japanese sculpture of the preceding Asuka period (552–646). The statue of which this head is a relic may be considered to have represented the beginning of Japanese Nara-style sculpture, although it was by no means a transitional work in itself. It embodied the direct importation of an already highly developed Chinese style.

THE YAKUSHI TRIAD IN THE GOLDEN HALL OF THE YAKUSHI-JI Some specialists maintain that the Yakushi Triad in the Golden Hall of the Yakushi-ji (Figs. 79, 82, 83, 98–100) must have been made in 718, when the Yakushi-ji was moved from the old capital at Fujiwara to the new one at Nara. It is my conviction, however, that it was commissioned in 680 and completed in 688. My first reason for this strong belief is based on stylistic

considerations: the triad is pure early T'ang in style, and this probably would not have been the case if it has been produced at a later date. Second, on the base section of the finial of the East Pagoda of the Yakushi-ji there is an inscription that mentions the Buddha Yakushi in what is most likely a reference to the main image of the temple. Third, whereas temple records and other documents clearly state that the Yakushi Triad was the main object of worship at the Yakushi-ji from the time of its founding, there is a complete lack of historical documents conducive to the supposition that the statues were not made until after the temple had been moved to Nara.

Although, as I have pointed out, the style of these three statues is a direct import from the sculpture of the early T'ang dynasty, it is immediately apparent that it has been modified somewhat by the artistic sensibilities of Japanese

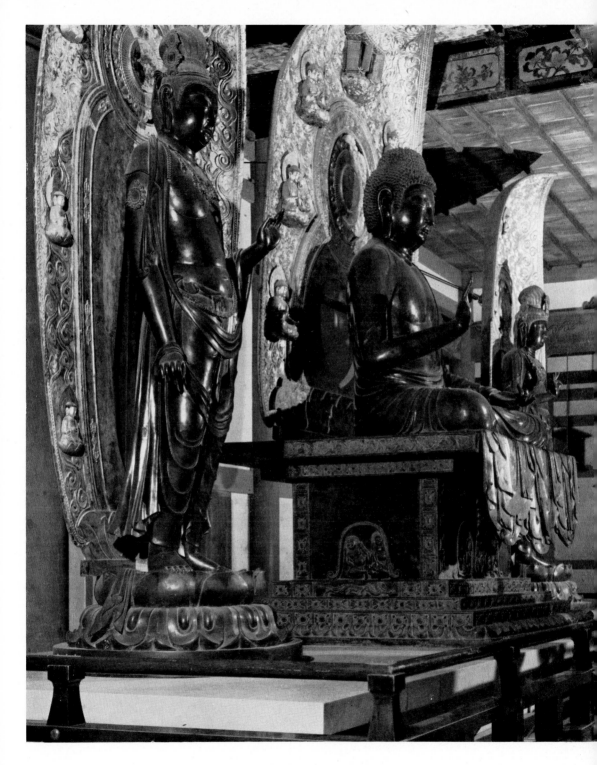

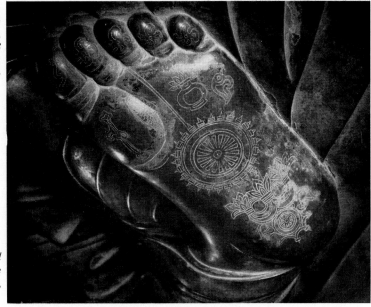

79. Yakushi Triad. At center, Yakushi Nyo-rai; at left, Gakko Bosatsu; at right, Nikko Bosatsu. Bronze; height of Yakushi Nyorai, 254.7 cm.; height of Gakko Bosatsu, 315.3 cm.; height of Nikko Bosatsu, 317.3 cm. 688. Golden Hall, Yakushi-ji, Nara. (See also Figures 82, 97–100, 142.)

80. Foot of Yakushi Nyorai, showing sacred symbols. Bronze; height of entire statue (see Figure 98), 254.7 cm. 688. Golden Hall, Yakushi-ji, Nara.

sculptors. For example, although the figures are thoroughly realistic, they seem to be infused with idealism. In other words, the faces and the poses appear to be completely human and natural, but the statues lack the intimate look of living human beings. They are exalted to the level of superlative representations of an enlightened Buddha and his attendant Bodhisattvas. The techniques that produced the lustrous areas of flesh and the gentle look of the soft folds of the garments leave nothing to be desired.

Despite certain differences in modeling, the statues of the Yakushi Triad, in their vigor and their fresh youthfulness, are closely related to the head of Yakushi from the former Yamada-dera. Similarly, although there are differences in sculptural expression between the Yakushi Triad and the various previously noted works of sculpture at the Todai-ji, they are all intimately related in style.

THE SHO KANNON IN THE TOINDO OF THE YAKUSHI-JI

Very little is known about the history of the Sho Kannon (Ary-avalokitesvara), the main image in the Toindo of the Yakushi-ji (Figs. 85–87, 101, 102, 111, 112). A temple legend holds that the imperial consort Hashihito—wife of the emperor Kotoku and sister of the emperor Temmu—ordered the production of this statue for the purpose of consoling the spirit of her deceased husband. It should be noted here that it was the emperor Temmu who commissioned the building of the Yakushi-ji.

If one accepts this legend—and I see no reason to reject it—the statue must have been made before the Yakushi-ji was moved from Fujiwara to its present location. Stylistic elements strengthen the possibility that this is true. For instance, although the statue is certainly in the T'ang style, it must be very early T'ang, for there is an immaturity in

81. *Detail of north side of pedestal of Yakushi Nyorai. Bronze; height of pedestal (see Figure 97), 150.7 cm. 688. Golden Hall, Yakushi-ji, Nara. (See also Figures 115, 144, 146.)*

the rendering of the flesh and the garments (Figs. 87, 101). The very fact that the statue does not represent Nara sculpture at its most sophisticated may account for the Sho Kannon's exquisite loveliness. The bronze casting is characterized by a rigidity in which we can see indications that this phase of production technique had not yet reached its apex when the statue was made.

In saying this, however, I do not imply any crudeness in the work. On the contrary, this is a vivid representation of the Bodhisattva in terms of early T'ang sculpture. An exalted formal principle underlies the whole concept. Part of the beauty of the statue arises from its resemblance to a youth of seventeen or eighteen years unspotted by knowledge of the evil of the world and assuming the form of a merciful Bodhisattva.

THE SHAKA-TAHO PLAQUE AT THE HASE-DERA

The famous bronze Shaka-Taho plaque at the Hase-dera, which illustrates a passage in the *Lotus Sutra* and pictures the Buddhas Shaka and Taho along with other Buddhas, Bodhisattvas, and a pagoda (Figs. 84, 103), bears an inscription stating that it was made in 698 by the priest Domyo and some eighty other priests and laymen as a memorial offering for the spirit of the deceased emperor Temmu. Today it is the main object of veneration at the temple. In the center of the plaque is a three-storied pagoda in moderately high relief. The building is surrounded by a simplified representation of the Pure Land, or paradise. The upper part of the plaque is filled with a thousand (figuratively) Buddhas rendered in repoussé. The inscription fills the

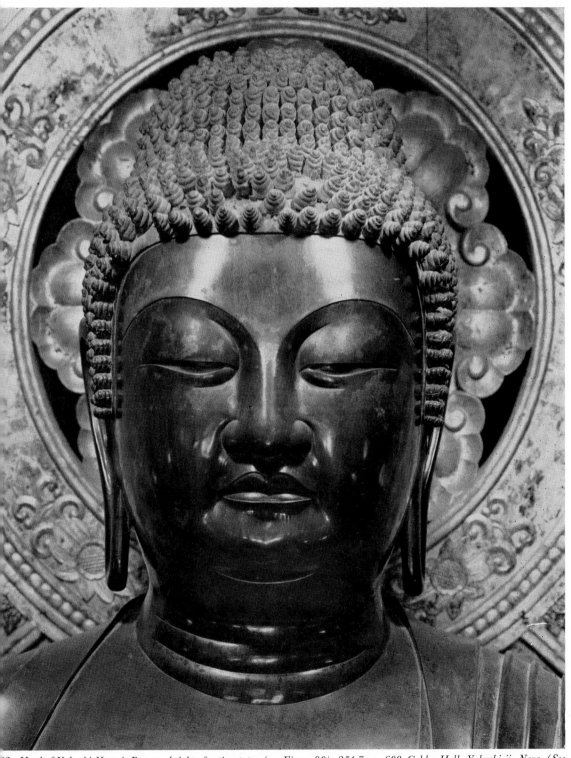

2. Head of Yakushi Nyorai. Bronze; height of entire statue (see Figure 98), 254.7 cm. 688. Golden Hall, Yakushi-ji, Nara. (See lso Figures 79, 80, 142.)

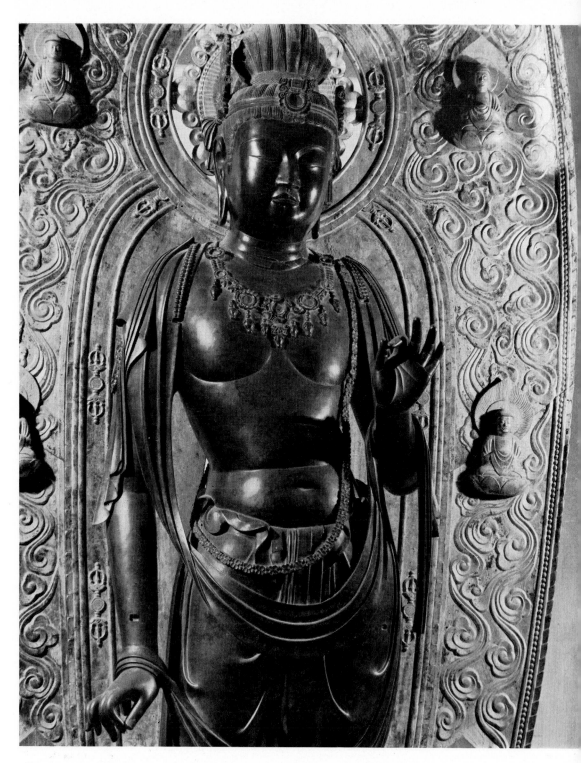

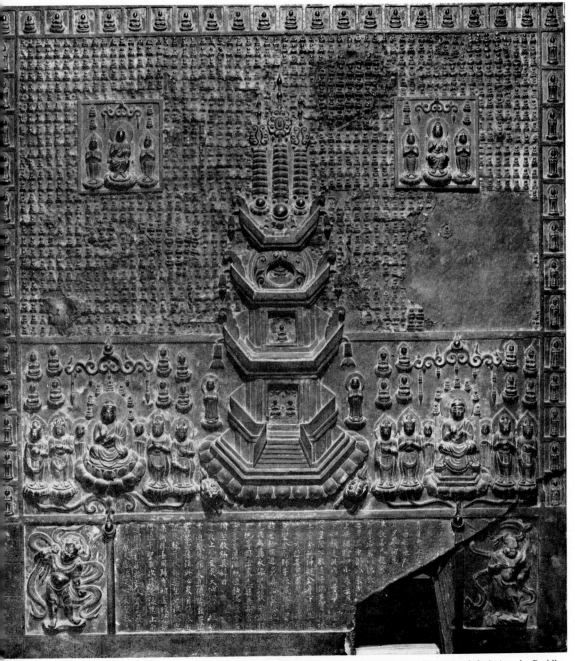

84. Plaque based on a passage in the Lotus Sutra and depicting the Buddhas Shaka and Taho, other Buddhas, Bodhisattvas, and a pagoda. Bronze; height, 84.3 cm.; width, 75 cm. 698. Hase-dera, Nara Prefecture. (See also Figure 103.)

3. Gakko Bosatsu. Bronze; height of entire ~~statue~~ (see Figure 79), 315.3 cm. 688. Golden ~~Hall~~, Yakushi-ji, Nara. (See also Figure 99.)

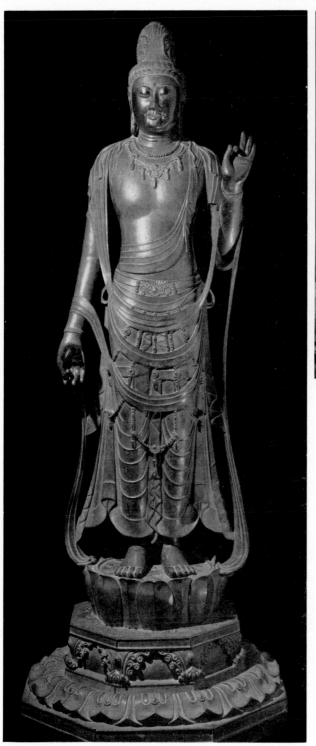

96 · THE TODAI-JI SCHOOL OF SCULPTURE

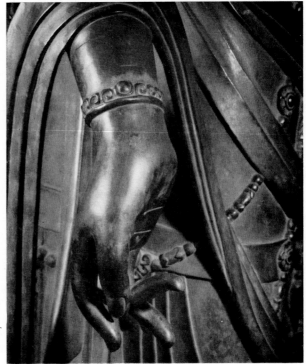

85 (opposite page, left). Sho Kannon. Bronze; height, 188.5 cm. Second half of seventh century. Toindo, Yakushi-ji, Nara. (See also Figures 86, 87, 101, 102, 111, 112, 143.)

86 (opposite page, right). Detail of Sho Kannon, showing headdress. Bronze; height of entire statue (see Figure 85), 188.5 cm. Second half of seventh century. Toindo, Yakushi-ji, Nara. (See also Figures 101, 102, 111.)

87. Detail of Sho Kannon, showing right hand. Bronze; height of entire statue (see Figure 85), 188.5 cm. Second half of seventh century. Toindo, Yakushi-ji, Nara. (See also Figures 101, 102, 111.)

bulk of the lowest part of the work and is flanked by representations of the Kongo Rikishi (Figs. 84, 147). The most prominent figures on either side of the pagoda are the Buddhas Shaka and Taho.

The faces and figures of the Buddhas and the attendant divinities are beautifully executed in the early T'ang style. They are fairly rounded, and they convey a sense of brightness and freedom, of relaxed liveliness.

T'ANG INFLUENCE IN EARLY NARA-PERIOD SCULPTURE It is very important to note that the sculpture of the early Nara period, as represented by the Yakushi head from the Yamada-dera, the Yakushi Triad in the Yakushi-ji Golden Hall, the Sho Kannon in the Yakushi-ji Toindo, and the bronze plaque at the Hase-dera, is unadulterated early

T'ang in style. Even when slight elements alien to this style managed to creep into some of the works, they were treated as no more than oddities of temporary interest, and they never persisted. Almost all the works that have been mentioned above are highly sophisticated and show no traces of anything even vaguely provincial in conception or execution.

The one exception among early Nara works has the effect of reinforcing my opinion regarding the stylistic purity of these pieces. The Gakuen-ji, in Shimane Prefecture, owns a bronze statue of Kannon that was made in 692 in the province of Izumo, as that prefecture was then called (Fig. 88). There is no doubt that the Kannon is an early Nara piece, yet it is characterized by marked regional traits. The important point in connection with the work, however, is the fact that it is the only known early

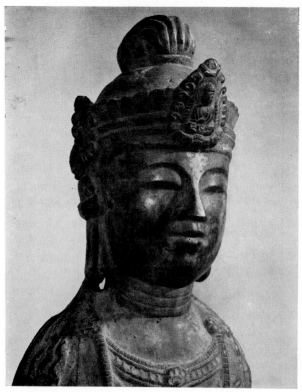

88. Kannon Bosatsu. Bronze; height of entire statue, 80 cm. 692. Gakuen-ji, Shimane Prefecture.

Nara statue that is not pure early T'ang in style. For this reason I feel safe in stating that the early T'ang style, borrowed in its orthodox and unadulterated form, developed into what is called the Nara style. Strong T'ang influence is indeed one of the salient distinguishing characteristics of the entire culture of Nara-period Japan.

THE SCULPTURE OF THE MIDDLE NARA PERIOD This same T'ang style, unaltered to any serious extent, was carried over into more mature Nara sculpture, which evolved some thirty years after the development of the early Nara style. The stylistic traits of mature Nara sculpture can be seen in the various statues created for the Todai-ji in connection with the completion of the Great Bud-dha. But other stylistic trends, as well, are to be seen in the sculpture of this age. For instance, what might be called the mid-T'ang style is represented by a number of works at the Horyu-ji: the clay statues in the ground level of the pagoda, in the niches of the Inner Gate, and in the Refectory, all of which were made around 711. Both in their style and in the technical methods used to produce them, they differ considerably from the clay statues at the Todai-ji. Let us look, for example, at the clay statue of Bon Ten in the Refectory of the Horyu-ji (Fig. 89). This work, which in its modeling and its expression closely resembles the stone Buddhas of the T'ang period, is unlike anything seen at the Todai-ji, and the rough manner of layering the clay is quite different from the technique employed in the Todai-ji works.

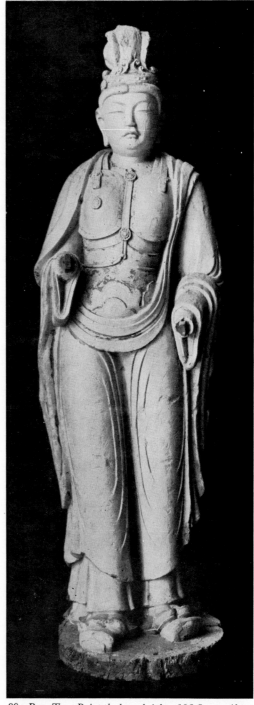

THE TWELVE GODLY GENERALS AT THE SHIN YAKUSHI-JI

The Shin Yakushi-ji (or New Yakushi-ji) was built in 747 under the direction of the same building authority that was responsible for the construction and embellishment of the Todai-ji. It is therefore not surprising that the statues found there should be related in style and production technique to the works of what I have called the Todai-ji school. In the Main Hall of the Shin Yakushi-ji, forming a circle around the central image of Yakushi Nyorai, stand the figures of the Twelve Godly Generals, or Juni Shinsho (Figs. 4, 90, 91, 109, 118, 119, 148–59). These statues, thought to have been produced in 748, bear a close resemblance to the statues of the Four Celestial Guardians in the Kaidan-in of the Todai-ji (Figs. 17, 18,

89. Bon Ten. Painted clay; height, 106.5 cm. About 711. Refectory, Horyu-ji, Nara Prefecture.

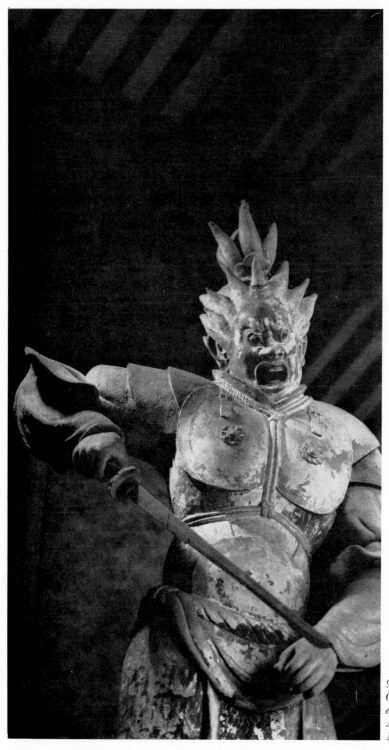

90. *Kubira Taisho, one of the Twel-
Godly Generals. Painted clay; height
entire statue (see Figure 156), 163.6 cm
About 748. Main Hall, Shin Yakushi-ji
Nara.*

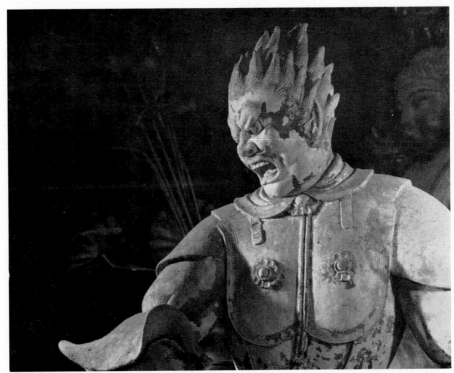

91. Basara Taisho, one of the Twelve Godly Generals. Painted clay; height of entire statue (see Figure 152), 166.8 cm. About 748. Main Hall, Shin Yakushi-ji, Nara. (See also Figures 4, 109.)

92. Relief carving of Buddha triad. Stone; height of central figure, 45 cm. Second half of eighth century. Zuto votive mound, vicinity of Shin Yakushi-ji, Nara.

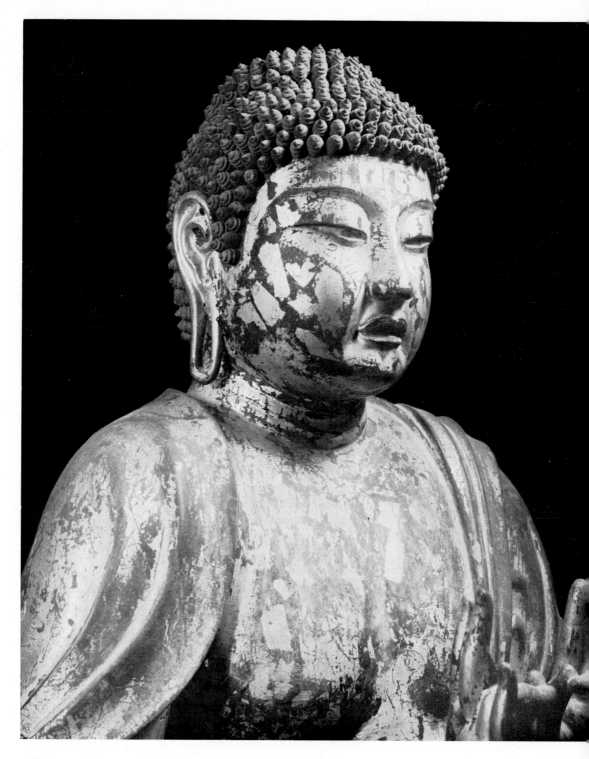

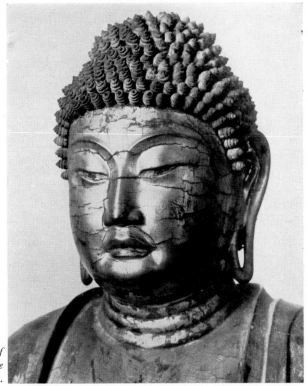

93. *Amida Nyorai. Lacquer and gold leaf on wood; height of entire statue (see Figure 22), 75.5 cm. 770–80. Saidai-ji, Nara.*

94. *Shaka Nyorai. Lacquer and gold leaf on wood; height of entire statue (see Figure 163), 72.1 cm. 770–80. Saidai-ji, Nara.*

1, 22, 60, 61, 138–41). They are classical examples of the Nara tendency to sacrifice realism for the sake of ideal forms. Within the wrathfulness of their facial expressions, one can almost trace a kind of humor. Such combinations of mood are typical of the Todai-ji school.

But certain differences between these statues and those of the Four Celestial Guardians at the Kaidan-in suggest that although they are definitely products of the Todai-ji school, they probably represent a subsidiary offshoot from the main stem. For example, although the coloring and the modeling of the two groups are similar, the Shin Yakushi-ji statues display a certain looseness and weakness in comparison with those of the Kaidan-in.

THE STONE RELIEF CARVINGS AT THE ZUTO

In attempting to determine how the Todai-ji school and sculpture in general developed during the late Nara period, it is important to look first at the stone relief carvings that decorate the Zuto, or Head Mound, which is located in the vicinity of the Shin Yakushi-ji. The carved stones, bearing representations of Buddhas and Bodhisattvas, are placed here and there on the surface of an artificially raised hillock that resembles the prototypical ancient Indian stupa—originally an earthen mound raised over holy relics of the Buddha. A popular, though unreliable, legend claims that the Zuto was erected over the head of the priest

95. Demon trampled under feet of Komoku Ten, one of the Four Celestial Guardians. Bronze. 765. Shiodo, Saidai-ji, Nara.

Gembo, who died in 746, in supplication for the repose of the soul of Fujiwara Hirotsugu, who met an untimely death in an uprising in Kyushu. It seems much more likely, however, that Roben (689–773), the most politically influential priest of his day and the man who encouraged and in fact commissioned much of the construction at the Todai-ji, had the hillock erected and the stones set in place in order to create something like the Indian stupa in its earliest form.

But the important point of this discussion is not so much the mound as the relief carvings on the stones placed here and there over its surface (Fig. 92). Although the quality of the stone itself is so coarse that the carving fails to achieve refinement, the Buddhas and Bodhisattvas have a typical Nara-style fullness of face and body and a bright general mood. Other features of the carvings obviously belong in the Nara tradition—for example, pavilion with towers, floral motifs in the canopies over the heads of the Buddhas, and the like. But a quality of laxness in the figures of the Buddhas and the Bodhisattvas themselves indicates that the greatest glory of the Nara style had already passed when they were created.

THE FOUR TRAMPLED DEMONS AND FOUR BUDDHAS AT THE SAIDAI-JI

The Todai-ji, or Great East Temple, was built in the eastern part of the city of Nara during the reign of the emperor Shomu. When his daughter ascended the throne as the empress Shotoku, she resolved to emulate her father's great building projects by

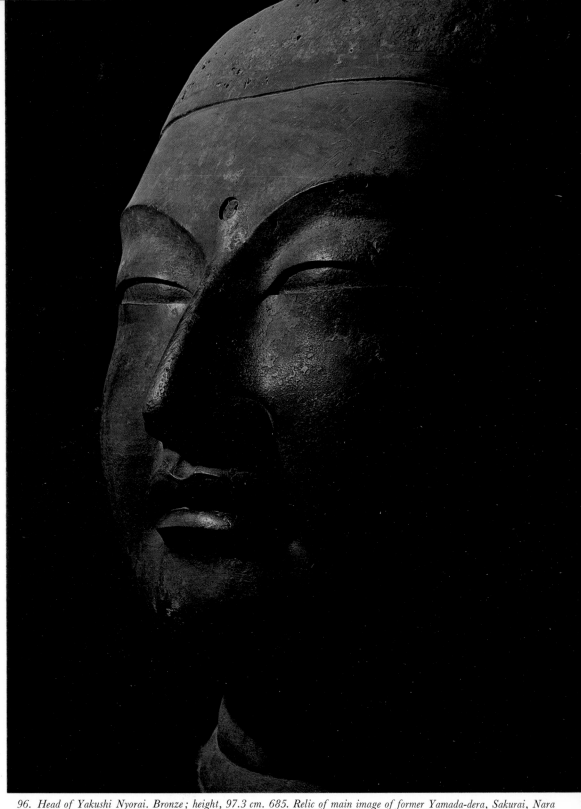

96. *Head of Yakushi Nyorai. Bronze; height, 97.3 cm. 685. Relic of main image of former Yamada-dera, Sakurai, Nara Prefecture. Kofuku-ji, Nara. (See also Figure 78.)*

97. *Detail of pedestal of Yakushi Nyorai, showing west side. Bronze; height of pedestal, 150.7 cm. 688.*
Golden Hall, Yakushi-ji, Nara. (See also Figures 81, 115, 144, 146.)

98. *Yakushi Nyorai. Bronze; height, 254.7 cm. 688. Golde*
Hall, Yakushi-ji, Nara. (See also Figures 79, 80, 82, 142.

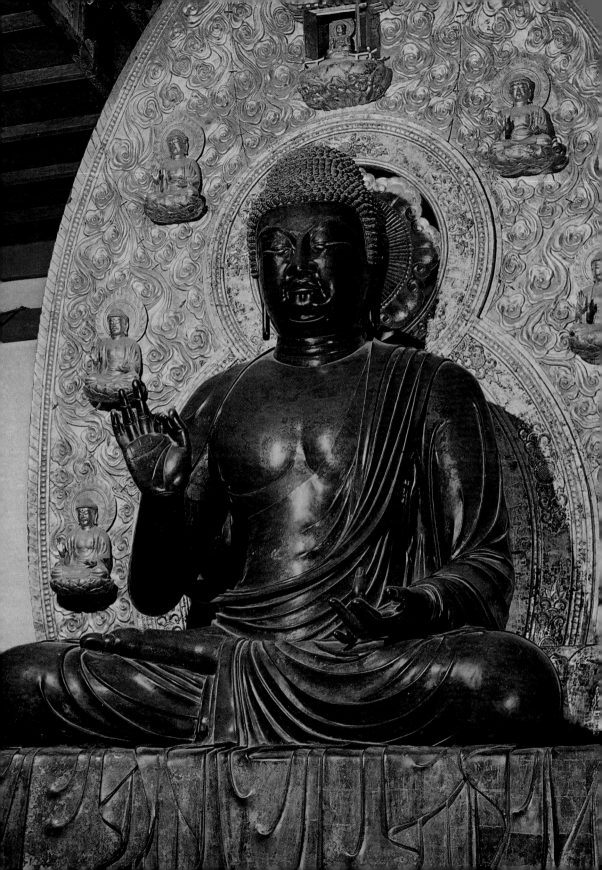

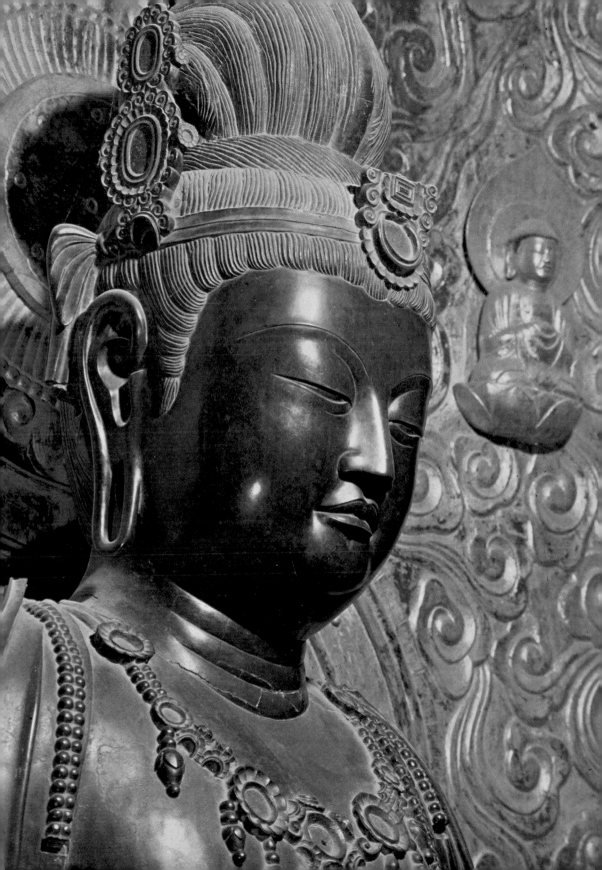

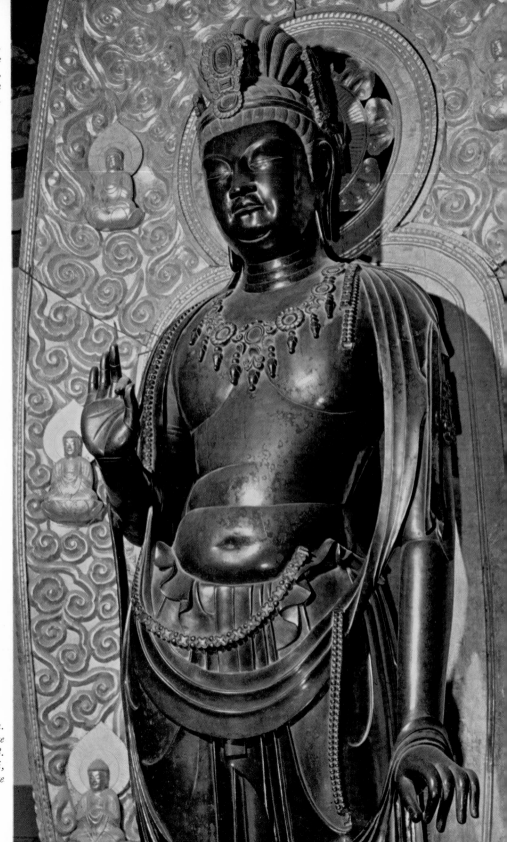

Gakko Bosatsu. [B]ronze; height of entire [stat]ue (see Figure 79), [31]5.3 cm. 688. Golden [Hal]l, Yakushi-ji, Nara. [See also Figure 83.)

0. Nikko Bosatsu. [Br]onze; height of entire [sta]tue, 317.3 cm. 688. [Go]lden Hall, Yakushi-ji, [Na]ra. (See also Figure [83].)

101, 102. Sho Kannon. Bronze; height of entire statue (see Figure 85), 188.5 cm. Second half of seventh century. Tōindō, Yakushi-ji, Nara. (See also Figures 86, 87, 111, 112, 143.)

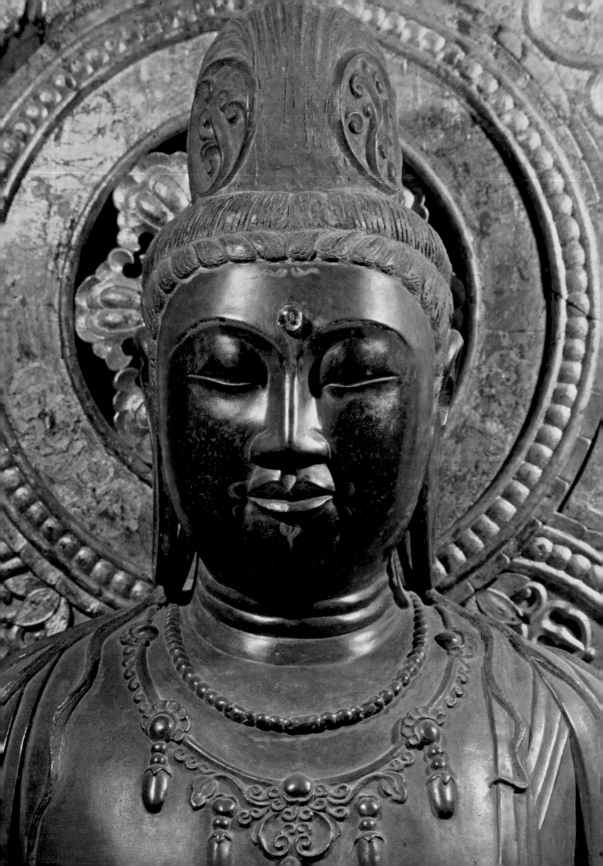

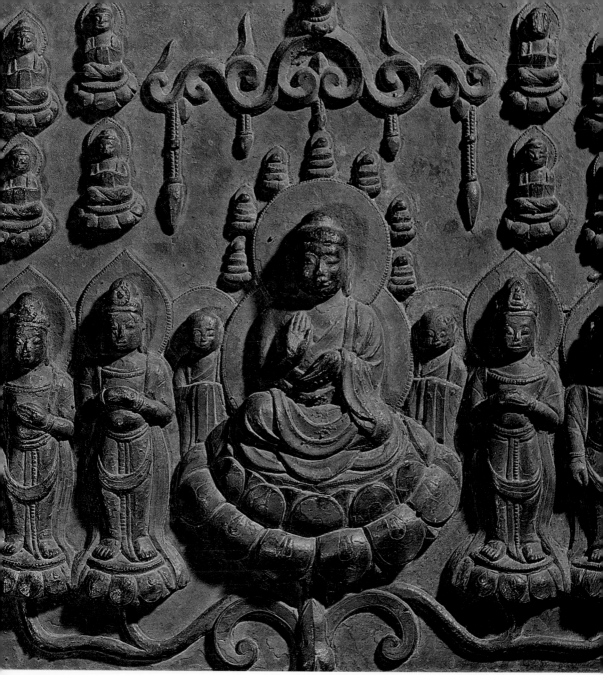

103. Detail of plaque based on a passage in the Lotus Sutra and depicting the Buddhas Shaka and Taho, other Buddhas, Bodhi-sattvas, and a pagoda. Bronze; dimensions of entire plaque (see Figure 84): height, 84.3 cm.; width, 75 cm. 698. Hase-dera, Nara Prefecture. (See also Figure 147.)

104. Demon trampled under feet of Jikoku Ten, one of the Four Celestial Guardians. Bronze. 765. Shiodo, Saidai-ji, Nara.

ommissioning the construction of a second large emple in the western part of the city. This temple was the Saidai-ji, or Great West Temple.

Unfortunately, however, the building and outfitting of the Todai-ji had so nearly emptied the national treasury that Shotoku was unable to deal s lavishly with her project as her father had done with his. Work on the temple began in 767 and was completed during the decade between 770 and '80. The major images were those of the Four Celestial Guardians and what are traditionally onsidered to be the four Buddhas Yakushi, Shaka, Amida (Amitabha), and Miroku (Maitreya). The tatues of the four Buddhas are thought to have been installed in the East Pagoda.

The construction and outfitting of the Saidai-ji did not proceed smoothly. It is said that the casting of the bronze statues of the Four Celestial Guard-

ians presented great difficulties and had to be repeated several times. Moreover, the stones for the foundations of the pagodas had to be transported from the distant hills east of the Todai-ji. At one point during the construction, which of course took place in a very superstitious age, it was learned that the stones were accursed, and the foundations had to be destroyed.

Traditionally the Four Celestial Guardians are shown trampling wicked demons underfoot. Today the demons once trampled under the feet of the Four Celestial Guardians at the Saidai-ji are the only vestiges of the original statues, which were destroyed in a succession of fires and were replaced in later ages. The four demons are richly varied, vigorous, and powerful in design and execution (Figs. 95, 104, 120, 121). If the workmanship is coarse in comparison with that of other works of

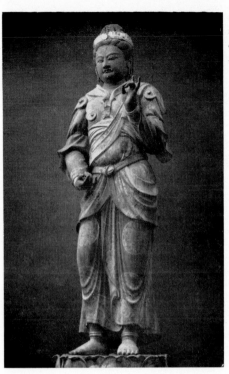

105. Taishaku Ten. Head: dry lacquer with colors, 780–806; body: wood with colors, Kamakura period (1185–1336). Akishino-dera, Nara.

106 (opposite page, left). Head of Gige Ten. Dry lacquer with colors; height of entire statue (see Figure 165), 212.2 cm, 780–806. Akishino-dera, Nara. (See also Figure 124.)

107 (opposite page, right). Head of Bon Ten (Brahma). Dry lacquer with colors, 780–806. Akishino-dera, Nara.

the period, it may be that the stringent financial conditions under which the temple was built were largely responsible. In addition, the fires and the rough treatment that the temple has suffered during its long existence have not improved the appearance of the statues.

Nothing definite is known about the date of the conditions of production of the four Buddha statues that are thought to have been originally enshrined in the East Pagoda of the Saidai-ji (Figs. 93, 94, 122, 123, 163, 164). Nonetheless, on the basis of style and sculptural technique, it is safe to assume that they were made not long before or not long after the building of the temple. That is to say, they are works of the late Nara period.

The strong but magnanimous facial expressions and the boldness of conception mark these Buddhas as being classically in the Nara style. Moreover,

the controlled brightness of the faces, the generosity of the folds of the garments, and the relaxed and free feeling of the composition in general make it safe to assume that, within the Nara tradition, these works belong in the general stream of the Todai-ji school. Still, the comparative heaviness of execution and the slight rigidity that one can sense in the very freedom of the conception lead me to believe that they are late works.

THE DRY-LACQUER SCULPTURE AT THE AKISHINO-DERA

The last temple to be built under the supervision of the Bureau for the Construction of the Todai-ji was the Akishino-dera, said to have been founded in 780 by the priest Zenshu. There are a number of reasons for accepting this date. First, we know that in 780 the imperial court assigned

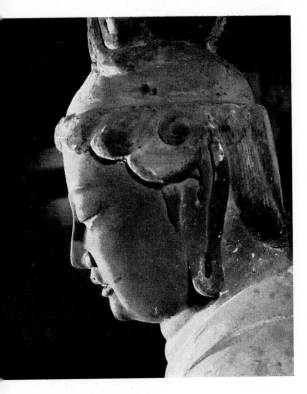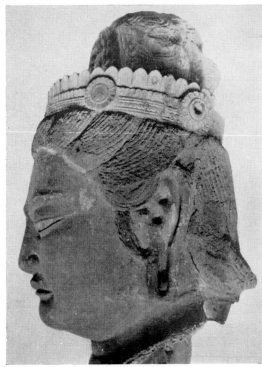

a parish of one hundred households to the temple for its support. We also know that in 785 the priest Zenshu enshrined in the temple a portrait of the imperial prince Sagara in supplication for the repose of the prince's soul. Again, the Bureau for the Construction of the Todai-ji is known to have been in charge of the building of the Akishino-dera in 787. And we know that in 806 memorial services were held there on the thirty-fifth day after the death of the emperor Kammu.

There are four works at the Akishino-dera that command interest as relics of Nara-period sculpture in its late stage. They are the figures of Gigei Ten (a patron divinity of the arts; Figs. 106, 124, 165), Bon Ten (Fig. 107), Taishaku Ten (Fig. 105), and the Bodhisattva Gudatsu. But only the heads of these statues are the original Nara-period dry-lacquer works, for the bodies are all wooden re-

placements of the Kamakura period (1185–1336). Although there are minor differences among the four heads, all of them have distinctively Nara-style eyes, eyebrows, and headdresses. The modeling of the cheeks is also characteristic of Nara Buddhist sculpture. Careful examination, however, reveals certain traces of change. For example, although the face of the Gigei Ten is gentle, it seems to have been produced by an art tradition past its prime. The profile of the Bon Ten is marked by sternness and lacks the bright quality that we associate with mature Nara statues. Again, in the modeling of the heads in general, we have evidence of an art that has reached its final stage. Just as the building of the Akishino-dera was the last project of the Bureau for the Construction of the Todai-ji, so it was also the last flowering of Nara-period creativity.

CHAPTER SIX

The Special Quality
of Nara Sculpture

IT IS OFTEN SAID that the sculpture of the Nara period is beautiful. Indeed, in looking back over the long history of Japanese sculpture and attempting to single out a number of the most superior works in its whole range, most people, even though personal tastes enter into such decisions, would not hesitate to name at least one Nara-period masterpiece—for example, the Yakushi Triad in the Golden Hall of the Yakushi-ji, the Sho Kannon in the Yakushi-ji Toindo, the Gakko Bosatsu in the Sangatsudo of the Todai-ji, or the Four Celestial Guardians in the Kaidan-in of the same temple. Certainly these statues, created some twelve to thirteen centuries ago, are among the greatest works of sculpture in the world. Why was it possible for the Japanese in the Nara period to produce art of this superlative quality? There are a number of reasons for this remarkable achievement.

The first of these involves the very nature of the Japanese nation at that time. Although the age was certainly not one of complete political stability and order, Japan was enjoying an enthusiastic outburst of energy as a nation united for the first time in its history. This energy found one of its important outlets in the creation of beautiful buildings and objects of art associated with Buddhist culture. The youthful exuberance of a newly formed nation was skillfully transmuted into the creation of works of art that even today speak eloquently of the vitality and passion of the people who made them.

The second reason has to do with the art that served as a model for the Nara-period masterpieces. Fortunately, in this age, Japan fell under the influence of T'ang China, the cultural pinnacle in the world of that time. Moreover, the T'ang culture that the Japanese chose as a model was that of the fresh and early years of the dynasty. Whether it was a matter of aesthetic perception or of emotional appeal, the Japanese found early T'ang art compatible with their own tastes and incorporated its styles almost unaltered into the sculpture of the Nara period.

There is a third reason for the Japanese artistic achievement in the Nara period. The actual artisans and artists who produced the statues obviously account for much of the merit of Nara sculpture, although in an unusual way. As I have already intimated, the sculpture of this age differed from that of later times with regard to the people who made it. In succeeding centuries it became the custom for one sculptor to produce each statue according to his own aesthetic standards within the limits established by iconography. This was not the case in the Nara period. Much of the sculpture of that time was produced by a rather large official organization within the bureau that was

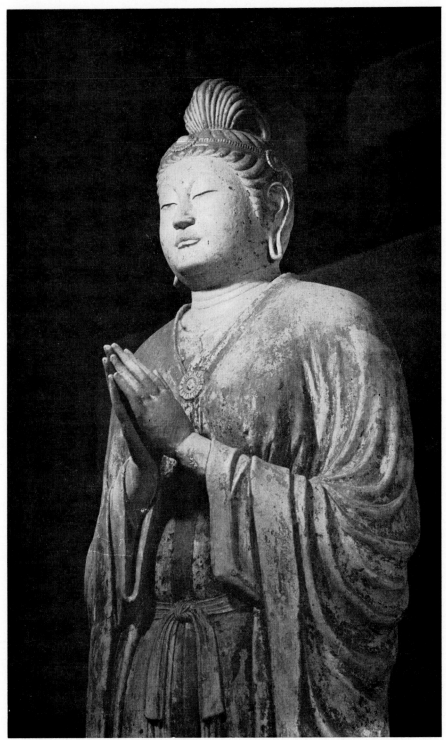

108. Gakko Bosatsu. Painted clay; height of entire statue (see Figure 130), 224.4 cm. 742–46. Sangatsudo, Todai-ji, Nara. (See also Figures 15, 45, 48, 50.)

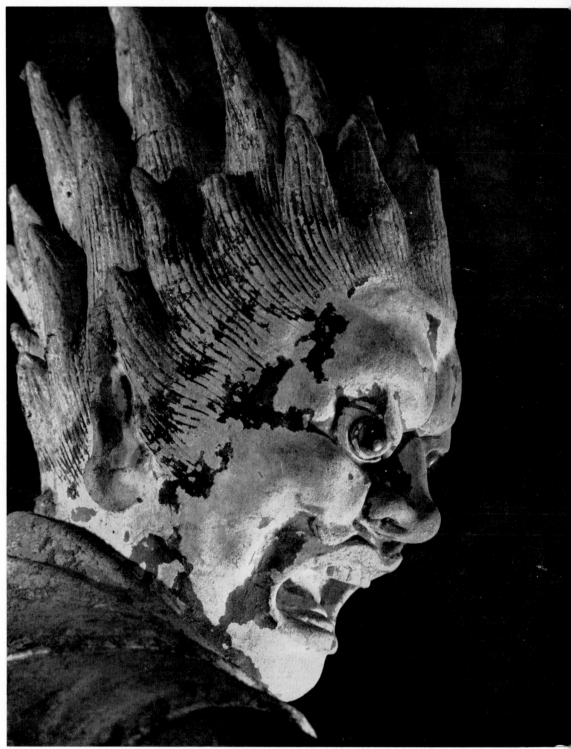

109. Basara Taisho, one of the Twelve Godly Generals. Painted clay; height of entire statue (see Figure 152), 166.8 cm. Abo[ut] 748. Main Hall, Shin Yakushi-ji, Nara. (See also Figures 4, 91.)

harged with the construction of a temple—for example, the Bureau for the Construction of the odai-ji—and individually produced works were uite rare. Of course the names of some individual ara-period sculptors are known, but each of these en was no more than a unit within the larger rganization, and his viewpoint as an independent rtist was probably not recognized. The organizaonal production system resulting from this aproach to sculpture left no room for the ideas or the esthetic proclivities of the individual artist. Consequently, the sculpture of the time represents the ge as a whole and speaks for the entire Japanese opulace. Nara sculpture was a product of the fforts of a large group of people possessed of much reater strength than could be mustered by a single uman being.

Finally, great outlays of money were patently ssential to the construction of the great Nara temles and to their embellishment with splendid orks of art. Since the imperial court directly financed almost all the projects, the financial support was more or less secure. But another aspect of the production system probably made the cost of each piece of sculpture or other work of art surprisingly low. To begin with, individual works were not commissioned. Instead, a large sum was set aside for the total art work for a given project. This meant that within the given limits it was necessary to set up an appropriate budget. Only the basic costs of materials were used as standards in estimating the outlay required for the works of art. It is true that materials were used lavishly in order to achieve outstanding artistic quality, but outlay for technical skill was nowhere recognized as necessary. The people who commissioned the buildings and the works of art of this period, the planners, the designers, and the craftsmen all approached their tasks with an admirable purity of intention. And it is this purity of intention that is reflected in the bright, unblemished quality of Nara-period sculpture.

Commentaries on Major Works of Nara Sculpture

THIS CHAPTER, intended as an elaboration of the main text, presents detailed information on the religious iconography, the methods of production, and the stylistic traits of the most outstanding works of Nara-period sculpture. The material is arranged according to the temples in which the works are housed. That is, I deal first with the statues in the Todai-ji itself and then go on to the early and the late Nara-period works found in other temples in the Nara area. For the reader's convenience, figure references are repeated from the preceding chapters.

BIRUSHANA BUTSU: THE GREAT BUDDHA OF NARA Because of the great age of Buddhism and the natural eclecticism that brought about its absorption of outside elements from the many countries and cultures through which it has traveled, the Mahayana Buddhist pantheon is enormous and at first glance hopelessly confusing. Even such an apparently basic issue as which Buddha occupies the position of paramount importance in the pantheon is difficult to determine, since different candidates have been advanced at various times and in various nations. For the purposes of this book, the period is the eighth century A.D., and the place is Japan—more specifically the capital city of Nara.

At that time and in that place, the Buddha Vairocana (in Japanese, Birushana or Rushana) was regarded as supreme.

The voluminous and difficult *Kegon-kyo,* or *Flower Wreath Sutra,* describes the enlightenment of Sakyamuni (in Japanese, Shaka Nyorai), the historical Buddha. In addition, it sets forth the doctrine of the complete interrelationship of all beings and all phenomena under the control of the supreme Buddha Vairocana, who dwells in the Land of Eternally Tranquil Light. He sits on a great lotus throne, each petal of which is a universe ruled by a Buddha. In religious terms, this cosmographic symbolism represents the belief that myriads of Buddhas are possible and that all beings contain in themselves inherent Buddhahood. The symbol of an all-powerful being ruling over a boundless universe in which harmony and total interrelationship of interests prevail was obviously valuable for the government of a newly unified nation.

The emperor Shomu, who was a very devout Buddhist, was eager to unify the nation culturally under Buddhism just as it was being unified politically. As we have already noted, he set up a system of provincial monastery-temples and convent-temples, the center of which was the Todai-ji in Nara. For the chief object of veneration in that temple, he decided to commission a colossal statue

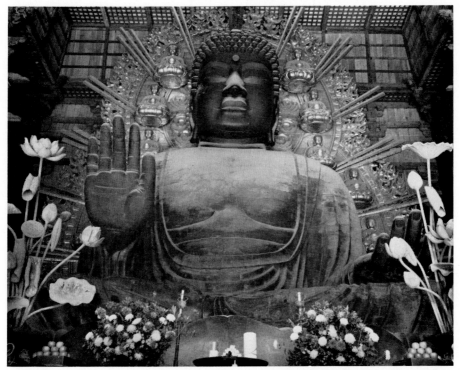

110. Birushana Butsu (the Buddha Vairocana), known as the Great Buddha of Nara. Bronze; height, 16.19 m. Originally completed in 757; restored in present form in 1692. Great Buddha Hall, Todai-ji, Nara. (See also Figures 25, 29–32.)

of the universal Buddha Vairocana (Figs. 25, 29–32, 110).

Two sutras served as the basis for the iconography originally employed in the statue and its lotus pedestal. The *Flower Wreath Sutra*, in which the nature of Vairocana is generally described, was an initial source of guidance and reference for the artisans who made the massive figure. The *Bommo-kyo*, or *Net of Brahma Sutra*, provided information concerning the Buddha worlds represented in the engravings that decorate the petals of the lotus pedestal.

In his great piety, the emperor Shomu stated his belief that the nation needed the protection that the tremendous statue would assure. At the same time, however, he expressed the wish that

the people should not be burdened by its production. It seems likely that his wish was unfulfilled, for the task of casting the Great Buddha was staggering. The project is said to have required about one million pounds of copper, tin, and lead for the statue itself and five hundred pounds of gold for the gilding. Fortunately, gold was discovered in a remote part of Japan at this time, and the emperor assumed that the discovery was a sign of divine approval for his ambitious undertaking.

The casting project itself entailed the construction of an immense basic earthen core and an outer mold. The molten metal was poured between the two, and the pouring was done in courses. An earthen mound was raised to the top of the first level of the outer mold. Caldrons were then raised

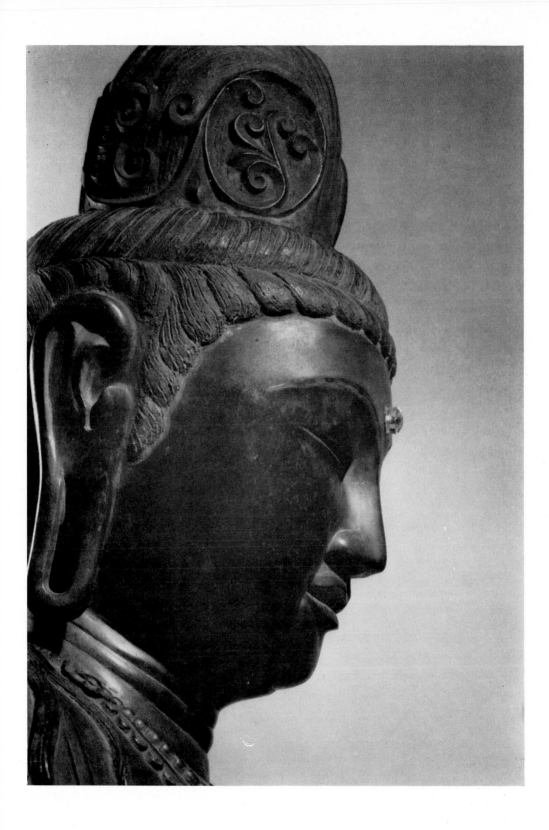

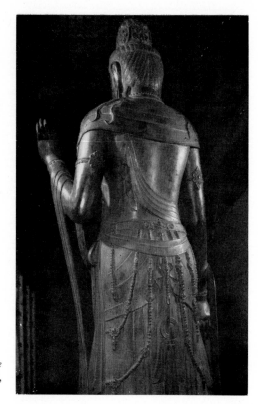

111 (left), 112 (right). *Sho Kannon. Bronze; height of entire statue (see Figure 85), 188.5 cm. Second half of seventh century. Toindo, Yakushi-ji, Nara. (See also Figures 86, 87, 101, 102, 143.)*

o the top of the mound for the melting of the metal. After the metal had been poured and allowed to cool, the mold for the next course was put in place. The earthen mound was then built up to the proper level, and the process was repeated until the statue was finished. Ultimately the metal resting on the huge basic mold was entirely encased in an outer shell of earth. Both the outer coating and the inner earthen core had to be removed after the metal had set and cooled. The gilding cost the lives of many workmen, who died of mercury poisoning.

The height of the Great Buddha is 16.19 meters, a measurement based on iconographical tradition. One of the largest standard heights for standing figures of the Buddha in Japan is *joroku*—that is, one *jo* and six (*roku*) *shaku*, or roughly five meters.

Seated figures of large size were made to half this height. A statue could be made in any multiple of either of these heights, and the Great Buddha of Nara is traditionally said to be ten times *joroku*. Since it is a seated figure, this would mean that it ought to be larger than it is. The discrepancy is related to units of measurement. In the Nara period, two units were used: the T'ang foot (*tojaku*) and the Chou foot (*shujaku*). Other large statues, including the Fukukenjaku Kannon in the Todai-ji Sangatsudo and the Yakushi Nyorai in the Golden Hall of the Shin Yakushi-ji, are known to have been made on the basis of the Chou foot, and it is entirely likely that the same unit was employed in the measurements of the Great Buddha.

As we have noted earlier, the statue has been

113. *Detail of canopy over Fukukenjaku Kannon. Colors on wood. 746. Sangatsudo, Todai-ji, Nara. (See also Figure 19.)*

114. *Detail of lotus pedestal of Great Buddha of Nara. Bronze. 757. Great Buddha Hall, Todai-ji. (See also Figures 27, 35, 36, and Foldout 1.)*

seriously damaged by fire, once in 1180 and again in 1567. The head and both hands are clearly restorations, and the shoulders show signs of having been repaired. Nevertheless, careful examination as to style and technique substantiates the assumption that the largest part of the trunk dates from the middle Nara period.

THE LOTUS PEDESTAL OF THE GREAT BUDDHA According to the *Flower Wreath Sutra,* the throne of Vairocana is a great lotus flower with a thousand petals, on each of which dwells a manifestation of Sakyamuni. Each petal is a universe and, as such, contains myriads of Buddhas in addition to Sakyamuni. The line engravings on the petals of the Great Buddha's lotus pedestal illustrate this idea (Figs. 27, 35, 36, 114; Foldout 1). On each petal is a representation of Sakyamuni surrounded by Bodhisattvas. Below him are the

thirty-three realms of the thirty-three divinities who dwell on Mount Sumeru, which, according to Buddhist cosmology, is the center of the universe. This auspicious peak is shown on the bronze petals as standing in the center of other mountains located immediately below the thirty-three realms. Finally, at the bottom of each petal are the seas that the ancient Indians believed surrounded Mount Sumeru. In other words, each petal is a cosmos in itself. This vastness of view was typical of ancient Buddhism, but it also had an important political symbolism for the Japan of the Nara period. The emperor was eager to show himself as the central figure in the nation and the Todai-ji and its great statue as the heart of all the nation's religious organizations. The thousand-petal lotus of the world of Vairocana ruled over by the one supreme Buddha accorded quite well with this imperial plan.

Stylistically, the line engravings on the lotus petals are classic examples of Nara art. The figures

re full, relaxed, and bright in temperament and mood. The lines are all quite firm. Indeed, such perfection is clear proof of the excellence of the artists and craftsmen assembled by the Bureau for the Construction of the Todai-ji.

THE BRONZE LANTERN AT THE GREAT BUDDHA HALL

The large octagonal bronze lantern that stands on a tall pedestal in front of the Great Buddha Hall at the Todai-ji was probably made only a short time after the dedication ceremonies for the Great Buddha in 752 (Figs. 23, 26, 33, 34). Lighting lanterns of this kind was considered a votive act and was supposedly effective in obtaining forgiveness for sins.

The roof of the Todai-ji lantern is ornamented with curling finials and is surmounted by a flaming jewel, one of the symbols of Buddhism. The eight panels of the light chamber are divided into two groups: four sets of double doors and four intermediary panels. All are in the form of diamond latticework. The sets of doors are ornamented with reliefs of Chinese lion-dogs arranged around the latches. But it is the remaining four panels that are more remarkable for their loveliness and for the light they shed on the aesthetic tastes of the middle Nara period. On each panel is a Bodhisattva in low relief. Each of the figures stands on two lotus blossoms and has a halo behind its head. All are playing musical instruments. The bodies, like the faces, are rounded and full, and draperies of extreme elegance and grace swirl around them. Strips of scrollwork run across the top and bottom of each panel, and the figures of the Bodhisattvas are surrounded by floral and scroll ornaments. Although the T'ang influence is readily apparent, these relief figures impress us first of all as reflections of the poetry and beauty of Nara in the days when it was the capital of Japan.

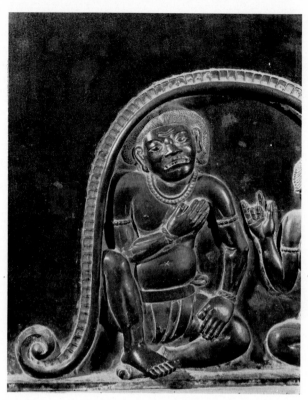

116. Demon trampled under feet of Komoku Ten, one of the Four Celestial Guardians. Painted clay. 742–46. Kaidan-in Todai-ji. (See also Figure 140.)

THE BIRTHDAY SAKYAMUNI Buddhist philosophy teaches that there are three distinct Buddha natures, which exist simultaneously. These are the nature of supreme happiness and wisdom, the nature of absolute purity dwelling in Nirvana, and the nature of mortal manifestation in the form of a living being who has arrived at enlightenment after countless transformations on earth. It is said that the Buddhas ranging from the past, through the present, and into the future are innumerable. The one known as Gautama Siddhartha, the historical Buddha, was born into his final mortal existence in the sixth century B.C. as the son of a minor chieftain of the Sakya clan in northern India and is therefore called Sakyamuni, or the Sage of the Sakyas. There are

many differing tales about his conception and birth. Immediately after he was born, he is supposed to have walked seven steps in each of the four directions and then, pointing to heaven with his right hand and to earth with his left, to have said: "Only I am honored in heaven and on earth." It is generally considered that he thereby asserted his claim to dominion over the world.

This appealing story has often been given artistic expression in the form of small statues of the infant Sakyamuni with his right hand pointing upward and his left hand pointing downward. In some lands, on April 8, the day traditionally honored as the birthday of Sakyamuni, perfumed waters are poured over small figures of this kind. In Japan, where this custom became popular in early times,

nd is still followed today, the perfumed waters
ave been replaced with a sweet tea called *amacha*.
he small statue used in the ceremony is usually
et in a basin and is called a Tanjo Shaka, or Birth-
ay Sakyamuni. April is a pleasant month in Japan,
nd the happy nature of the birthday celebration
aught the fancy of the Japanese.

Many Birthday Sakyamuni figures were made,
nd a surprisingly large number of them have
urvived. Aesthetically, however, the finest of
hese is the statuette at the Todai-ji (Figs. 28, 42).
he face is suitably plump and appealing, and the
eneral mood of the figure is bright. In all likeli-
ood, it was made around 752, the year of the
nagnificent dedication ceremony for the Great
3uddha.

The bronze basin in which the Birthday Sakya-
muni stands is the original one made for it, and in
this respect it is unusual, for the basins of many
similar statuettes have been lost. Line engravings
of birds, animals, and flowers cover the outer sur-
face of the basin (Figs. 41, 125).

THE SHIKKONGO SHIN The divinity Shik-
IN THE SANGATSUDO kingo Shin (or Shu-
kongojin) takes his
name from the fact that he bears in his right hand
a weapon known in Japanese as a *kongo* and in
Sanskrit as a *vajra* (literally, "thunderbolt"). His
Sanskrit name is Vajradhara, and in both lan-
guages the meaning of the name is "Thunderbolt
Bearer." In this connection the divinity is related

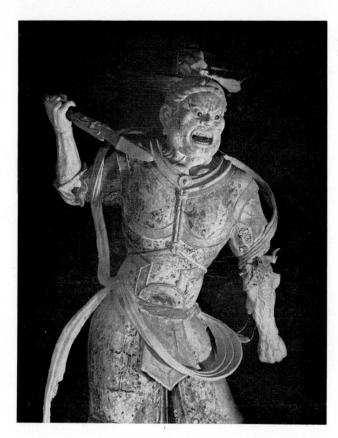

117. *Shikkongo Shin. Painted clay; height of entire statue (see Figure 12), 167.5 cm. About 733. Sangatsudo, Todai-ji, Nara. (See also Figures 6, 13.)*

118. *Mekira Taisho, one of the Twelv Godly Generals. Painted clay; height o entire statue (see Figure 148), 163.6 cm About 748. Main Hall, Shin Yakushi-ji Nara.*

to the Hindu god Indra, and in some parts of Asia he has been regarded as an Adi Buddha—that is, an eternal, ultimate Buddha residing in remote isolation from the universe of man. In Japan, however, this form of Vajradhara never gained a following, and he is best known as a guardian deity standing in constant vigilance to destroy the enemies of Buddhism. There are those who claim that this protective divinity derives from Devadatta, one of Sakyamuni's cousins, who was at first an implacable foe of Buddhism but later reformed and pledged himself to guard the Buddha at all times.

Representations of Vajradhara as a single deity are in keeping with the Buddhism of southern Asia, but in Mahayana countries, and especially in Japan, his function is usually divided between two figures known as the Kongo Rikishi (Vajrapani) o the Ni-o (Benevolent Kings). This division of the guardian task is apparently the outcome of purely functional considerations. The gates of temples are the usual places for representations of guardian divinities, and obviously a single statue can les effectively guard a temple than two. For this reason Vajradhara is represented in the form of the two Kongo Rikishi, or Ni-o, placed one on the right and one on the left in the niches of the temple gate.

Among the very few Japanese representations o Vajradhara—that is, Shikkongo Shin—the mos outstanding is the one in the Sangatsudo of the Todai-ji (Figs. 6, 12, 13, 117). It is likely that the

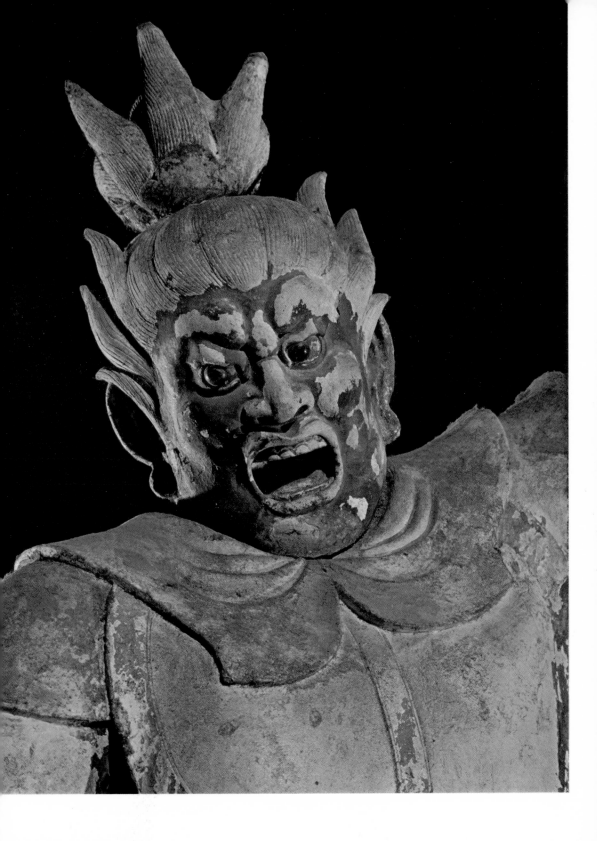

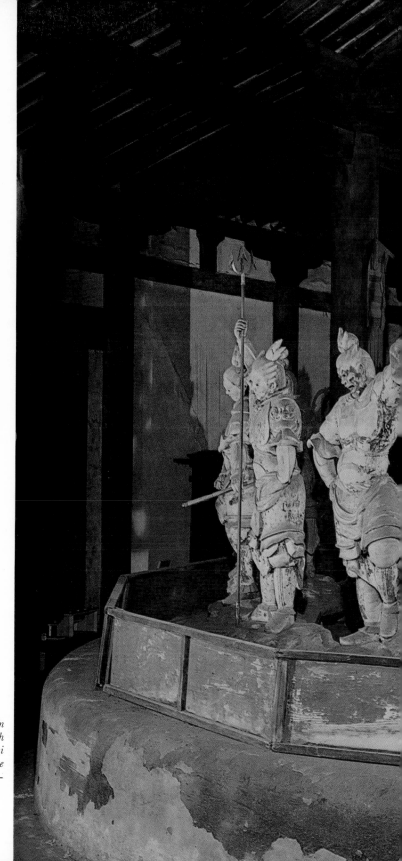

119. *View of inner sanctuary, Main Hall, Shin Yakushi-ji, Nara. Eighth century. The central figure of Yakushi Nyorai is surrounded by statues of the Twelve Godly Generals (Juni Shin-sho).*

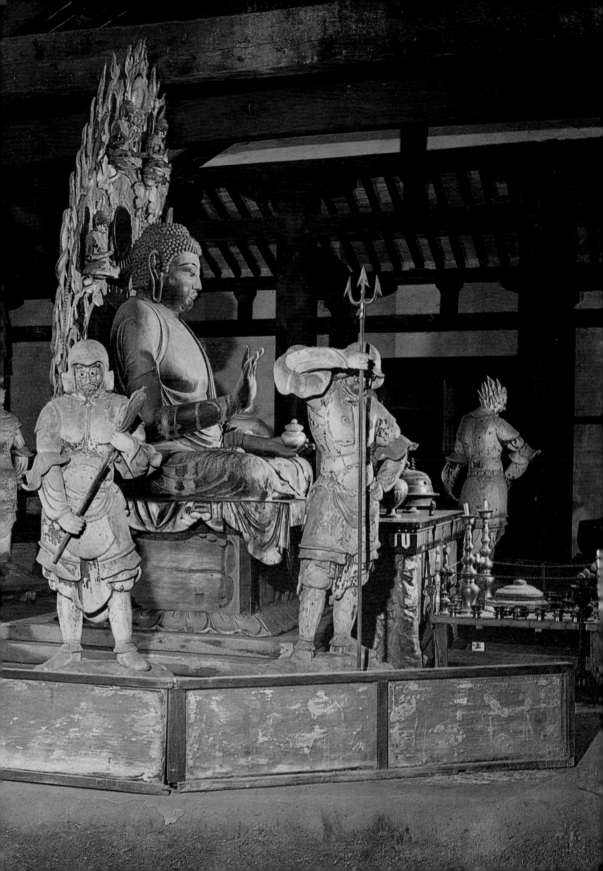

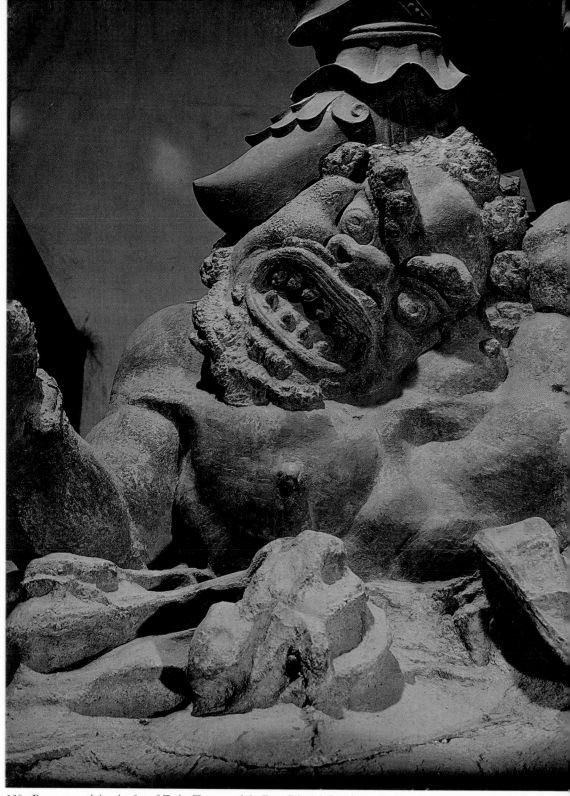

120. *Demon trampled under feet of Zocho Ten, one of the Four Celestial Guardians. Bronze. 766–67. Shiodo, Saidai-ji, Nara.*

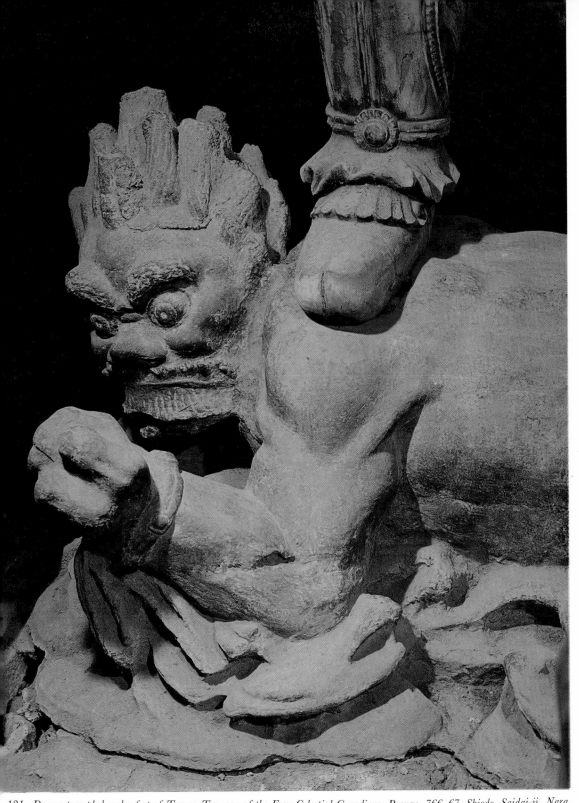

121. Demon trampled under feet of Tamon Ten, one of the Four Celestial Guardians. Bronze. 766–67. Shiodo, Saidai-ji, Nara.

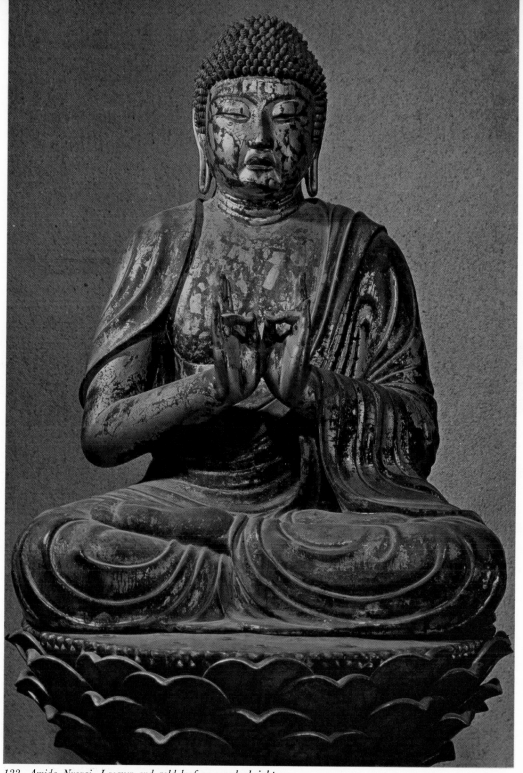

122. *Amida Nyorai. Lacquer and gold leaf on wood; height,*
75.5 cm. 770–80. Saidai-ji, Nara. (See also Figure 93.)

123. *Yakushi Nyorai. Lacquer and gold leaf on wood; height,* ▷
75.5 cm. 770–80. Saidai-ji, Nara.

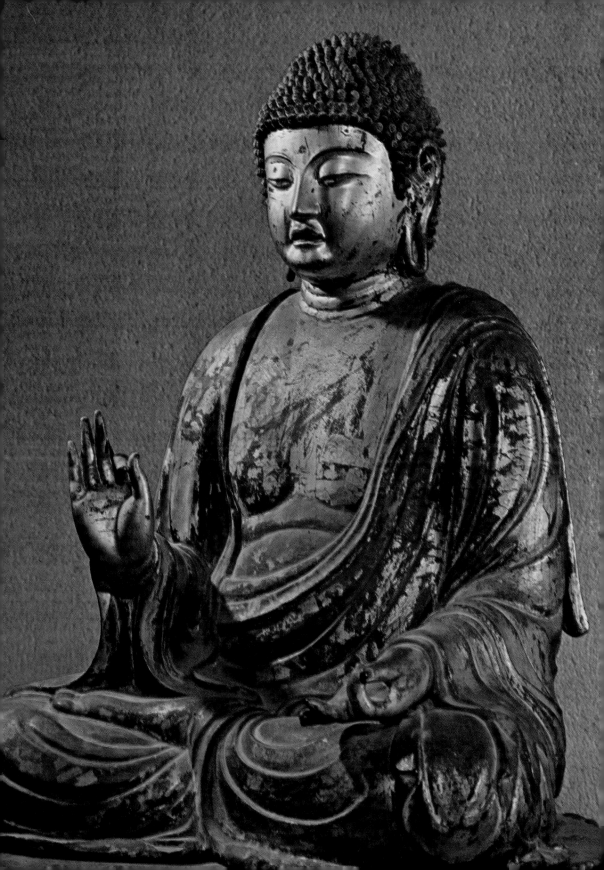

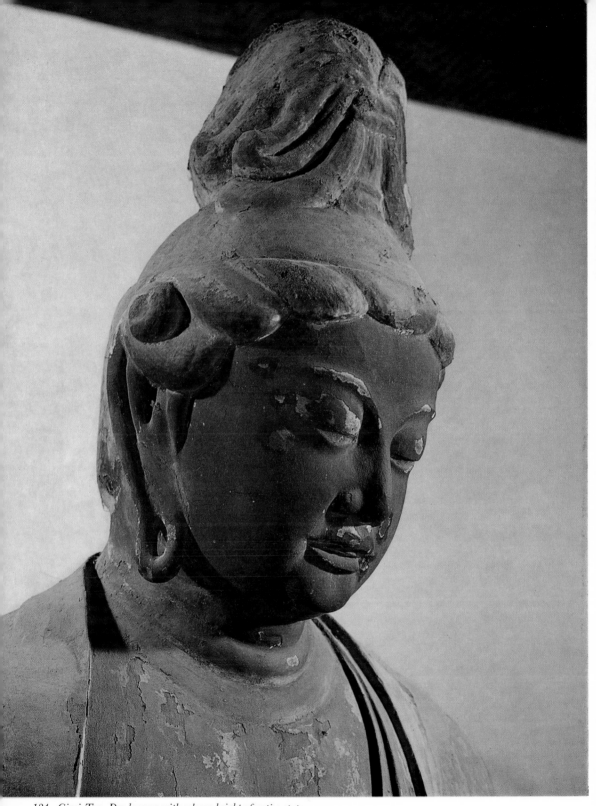

124. *Gigei Ten. Dry lacquer with colors; height of entire statue*
(see Figure 165), 212.2 cm. 780–806. Akishino-dera, Nara.
(See also Figure 106.)

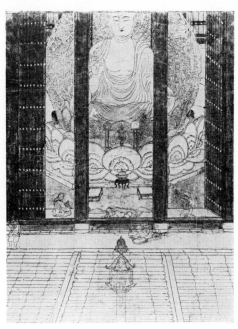

25. *Engravings on ablution basin of Birthday Sakyamuni. Bronze. About 752. Todai-ji, Nara. (See also Figures 28, 41.)*

26. *The Great Buddha of Nara seen through the doors of the Great Buddha Hall. Detail from the picture scroll entitled* Legends of Shigi-san Temple. *Twelfth century.*

priest known as Kinshu Gyoja commissioned the production of the statue for the Kinsho-ji, which, as has been explained earlier, antedated the Todai-ji. The sculptural and decorative styles employed in the figure are classic representations of Nara-period taste. The statue is in a remarkably good state of preservation, since for many years it has been regarded as a *hibutsu* (secret Buddha) and has thus been afforded maximum protection.

THE FUKUKENJAKU KANNON IN THE SANGATSUDO One of the great contributions of Mahayana Buddhism to religious thought is the Bodhisattva ideal. In the older and more conservative schools of Buddhism, of which the Hinayana schools are the surviving exponents, enlightenment and Nirvana can be attained only through one's own arduous efforts. Mahayana Buddhism, however, created the idea of the Bodhisattva, a being who has achieved

the state at which full Buddhahood is possible but postpones entry into Nirvana for the sake of helping others. The Bodhisattva represents the possibility of shared virtue and enlightenment, and the most famous of these self-sacrificing benefactors of mankind is the Bodhisattva Avalokitesvara, who is associated with the Buddha Amitabha (in Japanese, Amida) and is represented in many forms.

Avalokitesvara was worshiped quite early in China, where he came to be known as Kuan-yin, the god of mercy. Later associations with a deity called the Giver of Sons led to confusion concerning the sex of Kuan-yin, who is often represented in Chinese art as the goddess, and not the god, of mercy. This confusion has persisted to the present day, and some authorities insist that it is incorrect to regard Kuan-yin as belonging to either sex. Worship of Kannon (this is the Japanese reading of the Chinese name Kuan-yin) was introduced in Japan during the reign of the empress Suiko, which lasted

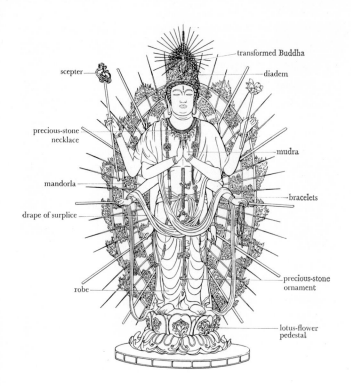

scepter

transformed Buddha

diadem

precious-stone
necklace

mudra

mandorla

bracelets

drape of surplice

precious-stone
ornament

robe

lotus-flower
pedestal

from 592 to 628, and, in one form or another, has maintained its popularity to the present day.

Some of the many forms of Kannon are tantric (Esoteric), and some are nontantric. Among the multiplicity of manifestations, the one of Fukuken-jaku Kannon (Amoghapasa) is probably the most powerful. Indeed, it may be that it is too powerful to accord with the compassionate, almost feminine quality usually associated with this Bodhisattva.

Fukukenjaku Kannon may be represented either seated or standing. He usually wears an elaborate diadem and has eight arms. The two major arms are brought forward to join the hands in a gesture of prayer, and the remaining six either form the charity mudra or hold objects symbolizing the attributes of the deity. The characteristic symbol of Fukukenjaku Kannon is the "never empty lasso" (*fukukenjaku*), which gives this form of the Bodhi-

sattva its name. Although man-made lassos and nets sometimes allow animals and fish to escape, the lasso of Fukukenjaku Kannon has the power to save all sentient beings without missing a single one.

In Japan, worship of Fukukenjaku Kannon was popular during the Nara period, when the statue in the Sangatsudo of the Todai-ji was produced, but the Bodhisattva was later replaced in popularity by less energetic and more compassionate forms of Kannon. The Sangatsudo statue (Figs. 5, 14, 15, 19, 20, 44, 46, 48, 49, 127) epitomizes the austere, powerful appearance of this form of the deity. The eight arms and the vertically placed additional eye in the forehead (the eye of wisdom, as it is called) contribute to the Kannon's dignity but considerably reduce its approachability.

The technique of making statues in dry lacquer

127 (opposite page, left). Line drawing of Fukukenjaku Kannon in Sangatsudo of To-dai-ji. (See Figure 48.)

128 (opposite page, right). Framework for a dry-lacquer statue. Wood. 780–806. Akishino-dera, Nara.

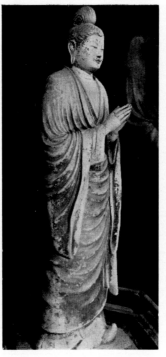

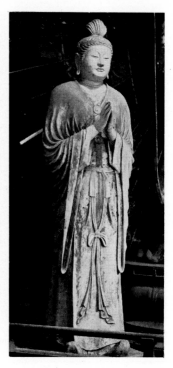

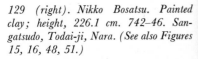

129 (right). Nikko Bosatsu. Painted clay; height, 226.1 cm. 742–46. Sangatsudo, Todai-ji, Nara. (See also Figures 15, 16, 48, 51.)

130 (far right). Gakko Bosatsu. Painted clay; height, 224.4 cm. 742–46. Sangatsudo, Todai-ji, Nara. (See also Figures 15, 45, 48, 50, 108.)

(kanshitsu) was especially well thought of in the Nara period, possibly because the relative flexibility of the materials allowed a degree of freedom in sculptural expression and from. The process by which the statues were produced, although not particularly complicated, must have been time-consuming. First a basic core was made of clay. On top of this was placed a layer of linen, which was then coated with lacquer. When the lacquer had dried, another layer of linen and another coat of lacquer were applied. This process was repeated until the materials had reached the desired thickness. The statue was then allowed to dry thoroughly. The clay core was removed from inside the statue, and a wooden frame was inserted to provide support (Fig. 128). Finally the statue was polished and then colored or gilded as the specifications required.

THE NIKKO BOSATSU AND THE GAKKO BOSATSU IN THE SANGATSUDO

The Nikko Bosatsu (Suryaprabha, or Sunlight Bodhisattva) and the Gakko Bosatsu (Candraprabha, or Moonlight Bodhisattva) are usually the attendants of Yakushi Nyorai (Bhaisajyaguru). Sometimes, however, they appear as attendants of Kannon. Furthermore, although they are not invariably shown in an attitude of prayer, the two Bodhisattvas frequently assume that attitude. This may account for the temple tradition at the Todai-ji that the two beautiful clay statues flanking the Fukukenjaku Kannon of the Sangatsudo are the Nikko Bosatsu and the Gakko Bosatsu (Figs. 16, 45, 50, 51, 108, 129, 130). But some specialists disagree with this identification. A study of the fit of the garments of the two figures suggests that they are

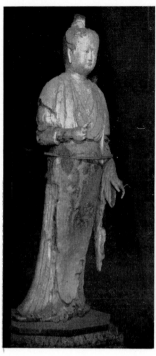
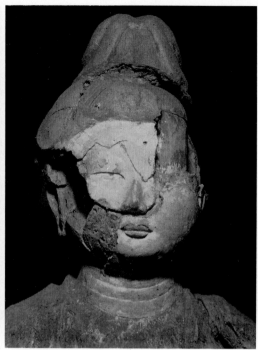
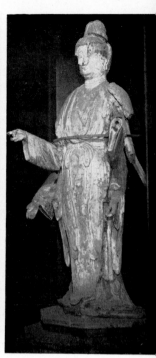

wearing armor under their outer robes. In ordinary iconography, armor would not be suitable to a Bodhisattva, but it is a standard attribute of guardian deities. For this reason, there has been advanced the plausible theory that the so-called Nikko Bosatsu and Gakko Bosatsu are in fact representations of Bon Ten (Brahma) and Taishaku Ten (Indra), who were introduced quite early into the Buddhist pantheon of protective divinities.

Although the Sangatsudo statues are made of fairly fragile clay, they have survived for more than twelve centuries in moderately good condition. The nature of the technique used in producing them may have something to do with their durability.

In the middle of the Nara period, many clay statues were made. Works of this type consist of a simple wooden core around which is built a rough approximation of the finished form in rough clay.

On top of this is another layer of finer clay mixed with a binder of linen rags. The final layer of clay —the layer in which the details are modeled—is of a still finer clay mixed with a binder of shredded paper. Color was used in the final finishing, although in the case of the two Bodhisattva statues most of it has worn off.

THE KICHIJO TEN AND THE BENZAI TEN IN THE SANGATSUDO

Kichijo Ten (or Kisho Ten) is an ancient Hindu deity (Srimahadevi) introduced into Buddhism as a goddess of beauty, wealth, and good fortune. So outright a female deity is unusual in Buddhism. Kichijo Ten is often shown wearing rich robes and jewels and carrying the fabulous *cintamani*, the jewel that has the power to satisfy all desires. Although she is generally as-

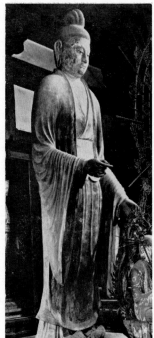
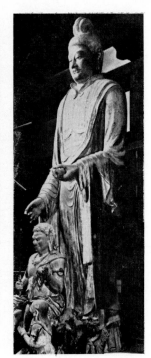

131 (far left). Kichijo Ten. Painted
clay; height, 218.8 cm. 772. Sangatsudo,
Todai-ji, Nara. (See also Figure 53.)

132, 133 (left center and left). Benzai
Ten. Painted clay; height, 218.8 cm. 772.
Sangatsudo, Todai-ji, Nara.

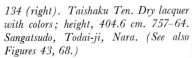

134 (right). Taishaku Ten. Dry lacquer
with colors; height, 404.6 cm. 757–64.
Sangatsudo, Todai-ji, Nara. (See also
Figures 43, 68.)

135 (far right). Bon Ten. Dry lacquer
with colors; height, 402.8 cm. 757–64.
Sangatsudo, Todai-ji, Nara. (See also
Figure 52.)

sociated with Esoteric Buddhism, which flourished
in Japan at a later time, as early as 767, prayers
were being offered to her throughout the country
for the sake of abundant harvests and protection
from disaster. In 772, full-scale services were con-
ducted in honor of the deity, and it is said that the
clay statue in the Sangatsudo was the image ven-
erated at that time (Figs. 53, 131).

The hall called the Kichijodo, in which the
statue was once worshiped, was destroyed by fire
in 954, and the statue itself was very badly dam-
aged. So severely has it suffered that it might seem
to offer little valuable information pertinent to the
history of Nara-period sculpture. This may in fact
be the case, but the figure reveals one fascinating
aspect of the attitude of the people of the time
toward Buddhist sculpture. Thanks to the damage
that time has done to it, layers of clay that would

normally be concealed have been brought to light.
In these layers the creases and folds of undergar-
ments can clearly be seen. To go to the extent of
representing the undergarments of a statue, even
though these were later covered with layers of clay
composing the outer garments, may seem a futile
procedure indeed, but here we have touching
evidence of the deep devotion to Buddhism and its
deities during the Nara period.

There is a scriptural basis for grouping together
the divinities Bon Ten, Taishaku Ten, Kichijo Ten,
and Benzai Ten as we see them in the ensemble of
statues in the Sangatsudo. Benzai Ten (Figs. 132,
133) was originally the Hindu goddess Sarasvati,
a patroness of music and poetry. In Japan she is
still a popular deity and, while often seen holding
a lute as a symbol of her musical and lyrical
function, is also often associated with snakes and

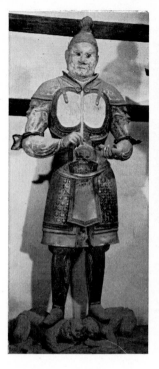

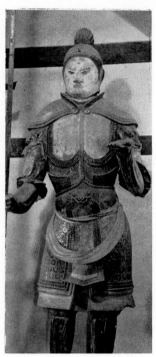

136 (far left). Komoku Ten, one of the Four Celestial Guardians. Dry lacquer with colors; height, 327 cm. 757-64. Sangatsudo, Todai-ji, Nara. (See also Figures 58, 160.)

137 (left). Tamon Ten (also called Bishamon Ten), one of the Four Celestial Guardians. Dry lacquer with colors; height of entire statue, 362 cm. 757-64. Sangatsudo, Todai-ji, Nara.

dragons for reasons that remain unclear but are obviously connected with folk beliefs. The statue of Benzai Ten in the Sangatsudo has suffered even more disfigurement than that of Kichijo Ten.

THE BON TEN AND THE TAISHAKU TEN IN THE SANGATSUDO

Bon Ten is the ancient and important Hindu god Brahma, creator of the universe. He is more accurately known in Japanese as Dai Bon Ten and in Sanskrit as Mahabrahma, and he was incorporated into Buddhism as a guardian deity. Examples of sculptural representations of Bon Ten in Japan are first found in the Nara period, and indeed the one now preserved in the Sangatsudo of the Todai-ji may be among the oldest (Figs. 20, 135). The cut of the garments of this statue, which are distinctively in the T'ang

style, suggests that the origin of the form as manifested in this version was Chinese. This assumption is reinforced by the size and power of the statue, both of which characteristics seem to have been borrowed from T'ang Chinese sculpture. Stylistic similarities among the Bon Ten, its companion statue the Taishaku Ten, the Four Celestial Kings, and the two Kongo Rikishi in the Sangatsudo lead one to suppose that all these works were designed and produced as a group, although it is uncertain whether they were originally planned for that building.

Taishaku Ten (Figs. 43, 68, 134), who is equivalent to the Hindu god Indra, is believed to reside in a palace of the summit of Mount Sumeru, the center of the universe in Buddhist cosmology. Like Bon Ten, he is a guardian deity, and statues of the two of them are often used together.

138 (right). Tamon Ten (also called Bisha-mon Ten), one of the Four Celestial Guardians. Painted clay; height, 176.9 cm. 742–46. Kaidan-in, Todai-ji, Nara. (See also Figure 21.)

139 (far right). Jikoku Ten, one of the four Celestial Guardians. Painted clay; height, 178.2 cm. 742–46. Kaidan-in, Todai-ji, Nara. (See also Figures 18, 22, 61.)

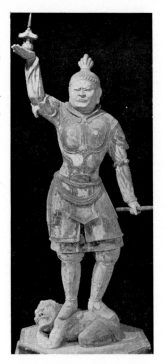

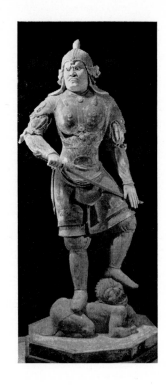

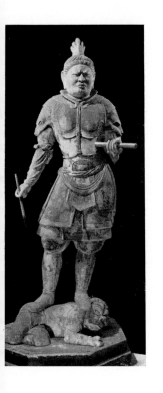

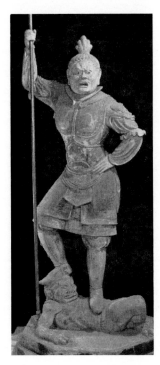

140 (far left). Komoku Ten, one of the Four Celestial Guardians. Painted clay; height, 163.5 cm. 742–46. Kaidan-in, Todai-ji, Nara. (See also Figures 60, 116.)

141 (left). Zocho Ten, one of the Four Celestial Guardians. Painted clay; height, 163.3 cm. 742–46. Kaidan-in, Todai-ji, Nara. (See also Figures 17, 62.)

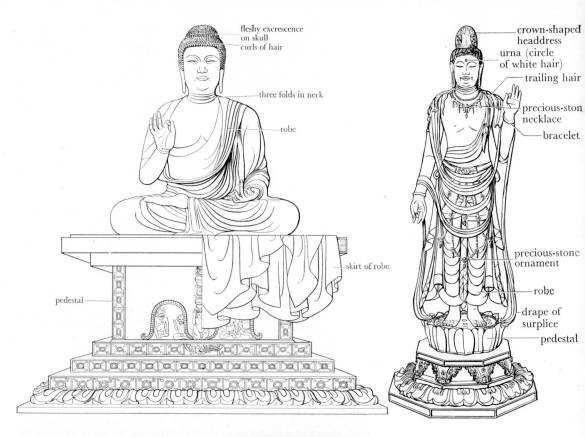

fleshy excrescence
on skull
curls of hair

three folds in neck

robe

skirt of robe

pedestal

crown-shaped
headdress
urna (circle
of white hair)
trailing hair

precious-ston
necklace

bracelet

precious-stone
ornament

robe

drape of
surplice

pedestal

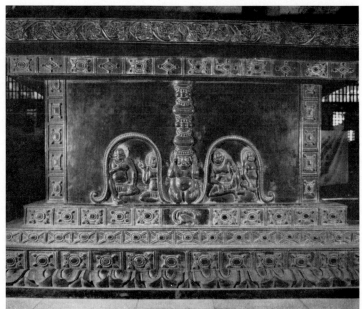

*144. North side of pedestal of Yakushi Nyorai.
Bronze; height of pedestal, 150.7 cm. 688.
Golden Hall, Yakushi-ji, Nara. (See also Fig-
ures 81, 97, 115, 146.)*

142 (opposite page, left). Line drawing
of Yakushi Nyorai in Golden Hall of Ya-
kushi-ji. (See Figure 98.)

143 (opposite page, right). Line drawing
of Sho Kannon in Toindo of Yakushi-ji.
(See Figure 85.)

145. Detail of pattern-dyed deerskin.
Eighth century. Todai-ji, Nara.

THE KONGO RIKISHI IN
THE SANGATSUDO
In relation to the
previously discussed
Shikkongo Shin in
the Sangatsudo, we have noted the role of the pro-
tective divinity armed with the *vajra,* or thunder-
bolt. We have also noted that single representations
of this divinity are much more rare than the pair of
guardians often found in temple gates, where they
glare and scowl in ferocious determination to ward
off anyone who would bring harm to the Buddhist
religion. Collectively known as the Kongo Rikishi
or, more familiarly, as the Ni-o, the statues are
usually placed so that the one with the open mouth,
called Misshaku Kongo, is on the west side of the
gate and the one with the closed mouth, called
Naraen Kongo, is on the east side. In temples
oriented in the traditional manner—that is, facing

south—this means that Misshaku Kongo is on the
left and Naraen Kongo on the right.

But it is not specifically prescribed that these
figures be placed in temple gates. In fact, their
logical placement is more accurately described as
a position at the entrance to the paradise or the
holy region of a Buddha. The oldest examples of
these statues used in Japan are often placed inside
a temple hall or somewhere other than a gateway.
For instance, in the Shaka-Taho plaque at the
Hase-dera, we see the Kongo Rikishi in the bottom
course of a representation of the Buddhist paradise
(Figs. 84, 147). They also appear in the representa-
tion of the Paradise of Miroku in the pagoda of the
Horyu-ji and in that of the Paradise of Shaka Nyo-
rai formerly in the West Golden Hall of the Ko-
fuku-ji. Consequently, it is reasonable to assume

146. Detail of east side of pedestal of Yakushi N
rai. Bronze; height of pedestal (see Figure 9
150.7 cm. 688. Golden Hall, Yakushi-ji, Nara. (
also Figures 81, 115, 144.)

that the statues of the Kongo Rikishi in the San-
gatsudo of the Todai-ji were made to be used in-
doors, although it is uncertain that their present
location is the original one (Figs. 54, 55, 67, 69).
The statues differ from the usual Kongo Rikishi in
their apparel. Whereas these divinities are ordi-
narily represented naked from the waist up and
rippling with dramatic, if not always anatomically
accurate, musculature, the Sangatsudo statues are
more sedately clothed in armor. This feature further
relates them to the Sangatsudo Shikkongo Shin,
whose military costume is similar to theirs.

THE FOUR CELESTIAL According to ancient
GUARDIANS IN THE Hindu cosmology and
SANGATSUDO to Buddhist cosmology
 in turn, the beautiful
Mount Sumeru, shaped like the seed pod of a lotus
and covered with gold and jewels, constitutes the
center of the universe. On each of the four sides of

this supreme mountain dwells a divinity who
responsible for guarding one of the four direction.
These are the Shitenno, or Four Celestial Guar
ians, who were incorporated from Hinduism int
the Buddhist pantheon. Individually they a
known as Tamon Ten, or Bishamon Ten (Vaisr
vana), guardian of the north; Komoku Te
(Virupaksa), guardian of the west; Zocho Te
(Virudhaka), guardian of the south; and Jikok
Ten (Dhrtarastra), guardian of the east. The Sut
of the Golden Light, which supplied much of th
foundation for political and religious actions of th
Nara period, describes how the Four Celesti
guardians promised to protect nations that woul
abide by the Buddhist teachings set forth in th
scripture. The Buddha, who was present when th
promise was made, gave it his sanction, and it lat
served as an excellent reason for rulers to insi
that the people of a nation abide by the precep
of the Sutra of the Golden Light and to order th

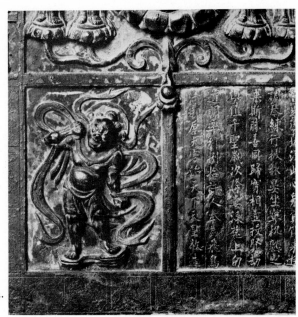

47. Detail of plaque based on a passage in the Lotus Sutra.
(See Figure 84.)

uilding of temples for the worship of the four
ivinities. This is precisely what was done in Japan,
where the Shitenno-ji (Temple of the Four Celestial
Guardians), located in present-day Osaka and now
reconstructed in original form, was the first such
institution built by the imperial court.

Numerous statues of the Four Celestial Guard-
ians were made during the Nara period. The
aidai-ji, as we have noted, was built with the idea
f enshrining such statues as major objects of vener-
tion. The worship of the divinities became ex-
remely popular in Japan, and each age has left
utstanding representations of them. The dry-
acquer statues in the Sangatsudo of the Todai-ji
re excellent Nara-period interpretations of the
our guardians (Figs. 47, 56–59, 77, 136, 137, 160,
61). Although their forms are somewhat vague,
hey have great dignity and a sense of magnanimity.
he scrolls and floral patterns ornamenting their
rmor are especially attractive, and they capture

for us something of the vigorously artistic mood of
the period.

THE FOUR CELESTIAL
GUARDIANS IN THE
KAIDAN-IN

Since statues of the
Four Celestial Guard-
ians were always made
as sets and never as
individual representations, they constitute an ex-
ample of group sculpture. In typical Oriental fash-
ion, the group of statues expresses both stillness
and action. For instance, one of the figures may be
seen standing quietly with tightly closed mouth and
somewhat narrowed eyes while another, with wide-
open mouth and large glaring eyes, assumes a
posture that threatens action at any moment. In a
word, the two figures are diametrically opposed
in aspect and attitude. This contrast between still-
ness and action, without being overemphasized, is
achieved with great effectiveness in the statues of
the Four Celestial Guardians in the Kaidan-in

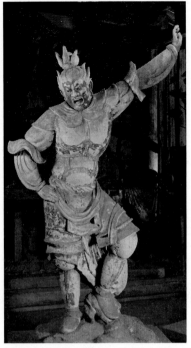
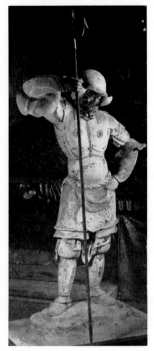
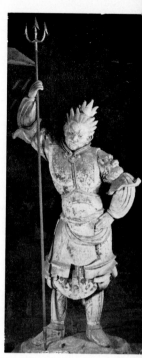

148–50. Mekira Taisho (left; see also Figure 118), Indara Taisho (center), and Santera Taisho (right), three of the Twelve Godly Generals. Painted clay; heights, 163.6, 157.6, and 157.6 cm., respectively. About 748. Main Hall, Shin Yakushi-ji, Nara.

of the Todai-ji (Figs. 17, 18, 21, 22, 60, 61, 138–41). In this respect, as well as in others, it is no exaggeration to describe the statues as masterpieces among masterpieces. It takes nothing more than a comparison of the faces of the Komoku Ten (Fig. 60) and the Zocho Ten (Fig. 17) to demonstrate the reasonableness of this opinion.

These statues are made of painted clay, a material that permitted greater freedom of expression than the other traditional materials of Japanese sculpture, and their modeling clearly reflects the masterly quality of the technique employed in their production. The bodies themselves are splendidly formed, but it is in the subtlety of detail that we find our best justification for calling the statues masterpieces—for example in the soft look of the silken garments and the hard look of the leather

armor. Both the superiority of the modeling and the strong sense of refinement displayed in these works are characteristic of Nara-period sculpture at its highest level of attainment, and it would be impossible to ask for greater excellence than we find here.

OTHER IMPORTANT
NARA-PERIOD WORKS
AT THE TODAI-JI

In addition to sculptural works of great historical and aesthetic value, the Todai-ji includes among its treasures a number of priceless craft articles dating from the Nara period and once owned by the emperor Shomu. In this book I do not deal with the immense collection of such treasures housed in the ancient repository called the Shoso-in, since these beautiful and fascinating ob-

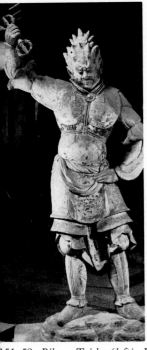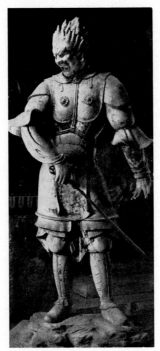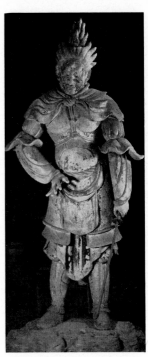

51–53. Bikara Taisho (left), Basara Taisho (center; see also Figures 4, 91, 109), and Shatora Taisho (right), three of the Twelve Godly Generals. Painted clay; heights, 163.6, 166.8, and 169.7 cm., respectively. About 748. Main Hall, Shin Yakushi-ji, Nara.

ects are the subject of another volume in the present series. I should, however, like to comment here on some Nara craft objects that are part of the collection of the Todai-ji itself.

Among the most interesting of surviving Nara-period craft objects are the masks used in the ancient dance performances known as Gigaku (Figs. 37–40, 64, 65). The Shoso-in has about 160 of these masks; the Horyu-ji, about 30; and the Todai-ji, about 10.

The comic dances in which Gigaku masks were used were probably imported from China, but little is known today of their content or their style. The coarse dances described as having been performed in Japan from the eleventh through the thirteenth century bore no relation to Gigaku, which had probably gone out of existence by that

time. Some of the Gigaku tradition may have persisted in ritual dances and entertainments involving the mythical long-nosed goblins called *tengu* or in the famous lion dances, for which a lion mask in Chinese style is indispensable.

In spite of the scarcity of information on the nature of the performances themselves, a considerable number of Gigaku masks have survived. The ones at the Shoso-in and the Todai-ji were almost certainly produced for performances that were part of the dedication ceremonies for the Great Buddha in 752. Most of them are made of paulownia wood, although some are of dry lacquer. The richness of form and emotional expression typical of these masks attests to the high level of craftsmanship reached in the Nara period.

The silver ceremonial container owned by the

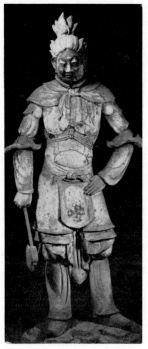 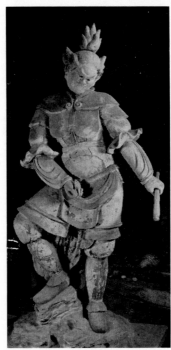 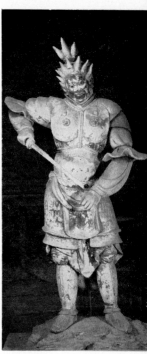

154–56. Makora Taisho (left), Shindara Taisho (center), and Kubira Taisho (right; see also Figure 90), three of the Twelve Godly Generals. Painted clay; heights, 166.7, 165.1, and 163.6 cm., respectively. About 748. Main Hall, Shin Yakushi-ji, Nara.

Todai-ji holds what is said to be one of the emperor Shomu's teeth (Fig. 162). More impressive than its contents, however, is the sophisticated craftsmanship evident in the form of the container and all its details, especially the simple flower of the knob on its lid and the hunting scenes and so-called fish-scale pattern on its exterior surface. The influence of T'ang workmanship and design as interpreted in Nara-period Japan characterizes this handsome piece.

Another interesting craft article in the Todai-ji collection is a section of pattern-dyed deerskin (Fig. 66). The original function of this object is uncertain, but it seems likely that it was once used as a wrapper for some kind of box. The leather is covered with a variety of designs rendered in white. Some of these are floral, scroll, and other ornamental patterns, while others depict landscapes with human figures or scenes of birds flying through clouds. All the designs are clearly of T'ang inspiration, and the piece has great value as reference material for the painting styles of both China and Japan in the seventh and eighth centuries.

THE HEAD OF YAKUSHI NYORAI FROM THE YAMADA-DERA

According to some traditions, the Buddha Bhaisajyaguru, known in Japan as Yakushi Nyorai, was already a Buddha when Sakyamuni was still a Bodhisattva. In any event, as the Buddha of Healing, Yakushi has been worshiped for many centuries in many lands, although apparently not in India. He is often represented in the company of the two Bodhisattvas Nikko and

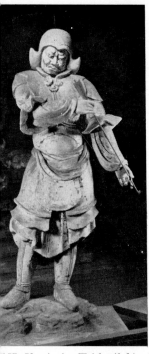 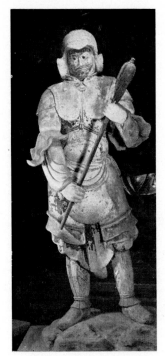 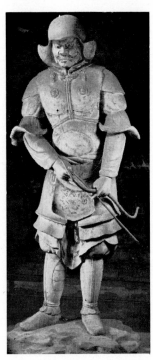

157–59. *Annira Taisho (left), Antera Taisho (center), and Haira Taisho (right), three of the Twelve Godly Generals. Painted clay; height of Annira Taisho, 156 cm.; height of Antera Taisho, 157.6 cm. Annira Taisho and Antera Taisho, about 748; Haira Taisho, restored by Hosoya Jiraku in 1928. Main Hall, Shin Yakushi-ji, Nara.*

Gakko, who are his assistants in bringing relief from suffering and in protecting the Buddhist law. Yakushi is an especially popular object of worship in Japan, and the statue of him in the Horyu-ji is one of the oldest works of sculpture in the country.

In the mid-seventh century a member of the powerful Soga family named Kurayamada no Ishikawamaro followed a course of political action that led first to great heights of authority and later to a tragic situation in which he was compelled to commit suicide in the temple Yamada-dera, which he himself had founded. For the repose of the soul of this unfortunate man, a triad of bronze statues centering on Yakushi Nyorai was commissioned and placed in the main hall of the temple. Later, as we have already noted, this Yakushi Triad was appropriated for the East Golden Hall of the Ko-

fuku-ji and was destroyed by fire in 1411. Today, all that remains of the original group of three statues is the head of Yakushi, which is housed in the Kofuku-ji Treasure Hall (Figs. 78, 96).

The head has suffered such great damage that at first glance it is difficult to identify it as true Nara-period sculpture. But since the date of the production of the Yakushi Triad is certain, the work is an excellent piece of reference material for the sculptural styles of the time. In spite of the damage and the serious warping of the forehead and the cheeks, the head reveals the fullness and beauty of the idealized Buddhas of early T'ang art. Admittedly, caution is needed in this kind of evaluation because of the condition of the relic, but the facial expression has the brightness characteristic of Nara-period sculpture.

160. *Leg of Komoku Ten, one of the Four Celestial Guardians. Dry lacquer with colors; height of entire statue (see Figure 136), 327 cm. 757–64. Sangatsudo, Todai-ji, Nara.*

THE YAKUSHI TRIAD AT THE YAKUSHI-JI Although only the head of the statue of Yakushi is left from the triad once enshrined at the Yamada-dera, at the Yaku-shi-ji one may admire a complete Nara-period Yakushi Triad, including the central image, the images of the Bodhisattvas Nikko and Gakko, and the superb pedestal on which the central image rests (Figs. 79–83, 97–100, 115, 142, 144, 146). Many knowledgeable people quite rightly insist that this triad is one of the finest examples of Buddhist art in the Orient. The statues, representing the full development of T'ang art in Japan, are both dignified and powerful, but at the same time they are characterized by extreme benignity and brightness. The precise modeling indicates technical sophistication of the highest order.

It has already been noted that there is some contention over the dating of the triad. Some claim that it must have been made when the emperor Temmu originally commissioned the building of the temple that housed it—that is, in the 680s. Others insist that it must have been made when the Yakushi-ji was moved from its original site to the present one in the second decade of the eighth century. Since there is no evidence that a new triad was made after the Yakushi-ji had been moved, I see no reason for assuming that the present statues are not the ones made for the original Yakushi-ji in the 680s.

The bronze pedestal on which the image of Yakushi Nyorai rests is a masterpiece among works of its kind (Figs. 81, 97, 115, 144, 146). The upper ornamental border is decorated with a design of

161. *Shoulder of Zocho Ten, one of the Four Celestial Guardians. Dry lacquer with colors; height of entire statue (see Figure 56), 363 cm. 757–64. Sangatsudo, Todai-ji, Nara.*

rapes and vines. Other bands bear flower and ewel motifs. In the center of the uppermost of the bottom bands on each side is the divinity who rules ver the direction in which that side of the pedestal aces: the Red Phoenix of the South, the Blue Dragon of the East, the White Tiger of the West, nd the tortoise-and-serpent combination known s the Dark Warriors of the North. The most interesting feature of the pedestal is to be seen in the arge panels of its four sides, where odd figures in uman form peer out from under bell-shaped rches. It is uncertain what these figures are supposed to represent. There are some who have uggested that they may be human beings, whereas thers believe them to be unusual depictions of the welve Godly Generals, who are associated with akushi Nyorai.

THE SHO KANNON AT THE YAKUSHI-JI

Kannon is the most beloved and most widely venerated of all the Bodhisattvas, those divinities who, although they have attained the level of enlightenment requisite to Buddhahood, postpone their own elevation voluntarily in order to help suffering sentient beings. Kannon takes many different forms, some of which are extremely complicated. The Sho Kannon (literally, "Sacred Kannon") is the earliest and one of the simplest of the many manifestations of the Bodhisattva. Corresponding to the Indian Bodhisattva Aryavalokitesvara, he is usually represented as a slight, graceful young man and is often richly ornamented with jewels. His hair is worn piled high in an elaborate decorative headdress. His symbol is the lotus blossom, and he

*162. Miniature covered bowl dec-
rated with hunting scenes. Gilde
silver; height, 4.4 cm. Eighth cen-
tury. Todai-ji, Nara.*

is therefore also known in Sanskrit as Padmapani, or the Lotus Bearer, but he does not always carry this symbol. The exquisite statue of the Sho Kannon in the Toindo of the Yakushi-ji shows him without it, although it is otherwise similar to orthodox representations of the Bodhisattva (Figs. 85–87, 101, 102, 111, 112, 143).

If I were asked to select the most beautiful statue in the whole range of Japanese sculpture, I would not hesitate to choose the Yakushi-ji Sho Kannon. It represents the Japanese inheritance of the young and vigorous T'ang style, and its benign facial expression and the purity and innocence of the entire conception speak directly even to the people of our own day. Unlike the serene but aloof statues of Buddhas, this figure of the Bodhisattva is fundamentally human, although on a very high level of humanity. The fullness of the face, the body, and the limbs reminds us of human beings, but perhaps it is the modeling, which suggests spotless yet com-

pletely developed youth, that touches the beholde most deeply. Indeed, the youthfulness of the statue gives us the impression of a bud about to burst int bloom. For this reason, I consider the beauty of th Sho Kannon an incomplete beauty—the beauty so to speak, of something about to become mor than it is at the present moment.

THE SHAKA-TAHO
PLAQUE AT THE
HASE-DERA

This celebrated bronz plaque has already bee discussed in some detai in Chapter Five. It is il lustrated in Figures 84, 103, and 147. The inscrip tion at the bottom of the plaque makes it reason ably certain that it was produced in 698. The scen depicted is based on a passage in the *Lotus Sutra* i which a "treasure tower" (stupa or pagoda) described. To the right and the left of the pagod are the figures of the Buddhas Shaka and Taho an their attendant Bodhisattvas. Taho (Prabhutarat

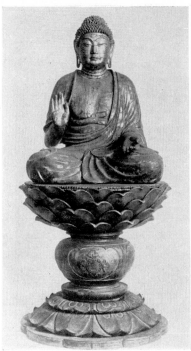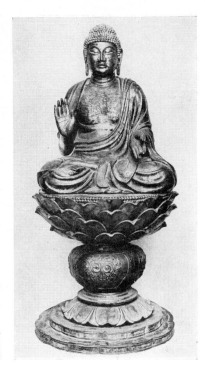

163 (right). Shaka Nyorai. Lacquer and gold leaf on wood; height, 72.1 cm. 770–80. Saidai-ji, Nara. (See also Figure 94.)

164 (far right). Miroku Nyorai. Lacquer and gold leaf on wood; height, 71.2 cm. 770–80. Saidai-ji, Nara.

na) is the Buddha who is said to have appeared to Shaka while he was expounding part of the *Lotus Sutra* and to have praised him for his performance. In addition to the pagoda and the two chief Buddhas, the plaque pictures other Buddhas and Bodhisattvas and, in its upper part, "one thousand" (the number is figurative) small Buddhas in repoussé. The style of the piece is early T'ang, as the vigor and strength of even the smallest figures indicate. The depictions of the Kongo Rikishi in the bottom section of the plaque are the oldest surviving Japanese representations of these divinities.

THE TWELVE GODLY GENERALS AT THE SHIN YAKUSHI-JI

The Twelve Godly generals derive from ancient Hindu mythology and were incorporated into the Buddhist pantheon as guardian divinities of the Buddha Yakushi. Each has the assignment of guarding the Buddhist law against danger from one of the twelve directions of the compass: north, north-northeast, east-northeast, east, east-southeast, south-southeast, south, south-southwest, west-southwest, west, west-northwest, and north-northwest. Since each of the directions is associated with an animal of the Oriental zodiac, the Twelve Godly Generals themselves came to have associations with these animals, and in Japan, from around the last years of the twelfth century, it became the custom to portray each general with his appropriate animal above his head. In the Nara period, however, the generals were regarded simply as the guardians of the twelve directions. At some stage in history a good deal of confusion concerning their names developed, and today, in representations that lack the symbolic animals, it is difficult to identify the individual generals with any certainty. The Shin Yakushi-ji statues fall into this category, and it should be noted that the names they bear in this book are the ones assigned to them by tem-

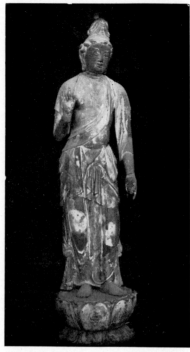

165. *Gigei Ten. Head: dry lacquer with colors, 780–806; body: wood with colors, Kamakura period (1185–1336). Height, 212.2 cm. Akishino-dera, Nara. (See also Figures 106, 124.)*

ple tradition (Figs. 4, 90, 91, 109, 118, 119, 148–59).

Although the Twelve Godly Generals seem completely at home standing in a circle around the central image of Yakushi Nyorai and facing outward as if to protect him, there is some doubt that they were originally produced for this temple. According to extant records, the statues were moved to their present location from a nearby temple called the Iwabuchi-dera. Inscriptions in ink on the pedestals of some of the statues refute these records by stating that they were produced in 748 by workmen connected with the Bureau for the Construction of the Todai-ji. This may be the case, but the stylistic laxity and the lack of strength apparent in these figures when they are compared with the Four Celestial Guardians in the Todai-ji

Kaidan-in indicate that even if they were made under the supervision of the bureau, they were considered secondary works not worthy of the attention lavished on the statues for the Todai-ji.

THE FOUR TRAMPLED DEMONS AT THE SAIDAI-JI

In 764, the then retired empress Koken commissioned the construction of the Saidai-ji, the Great West Temple that was to be the rival of the Todai-ji, or Great East Temple. In 765, after she had emerged from retirement as the empress Shotoku, the actual work of building the temple began. The chief object of worship in this grandiose temple—a temple that incorporated the latest in startling Chinese decorations—was to be a group of statues of the Four Celestial Guardians.

ut the drainage on the imperial purse occasioned
uring the period of temple building that produced
e Todai-ji had been so immense that serious
ouble was encountered in producing the statues
r the Saidai-ji. Nevertheless the casting of the
atues began in 766 and was completed in 767. In
e centuries that followed, these works suffered
peated damage in fires and other disasters, and
·day nothing of the figures of the original Four
elestial Guardians remains but the demons once
ampled under their feet (Figs. 95, 104, 120, 121).
he guardians themselves have been replaced by
atues produced in later times.

The trampled demons, although frequently dam-
zed and extensively repaired, more or less preserve
eir original forms. The group is highly varied,
ut each of the figures is suitably demonic. All are
aracterized by vigor of line and generosity of
rm. It is quite clear that they belong to the great
adition of Nara sculpture.

HE FOUR BUDDHAS According to temple
T THE SAIDAI-JI tradition, the four Na-
 ra-period Buddha stat-
es at the Saidai-ji were once enshrined in the now
anished East Pagoda (Figs. 93, 94, 122, 123, 163,
64). Actually almost nothing certain is known
bout them, and it is even impossible to say exactly
hich Buddhas they represent. The temple assigns
em the names of Shaka, Amida, Hosho (Ratna-
ambhava), and Ashuku (Aksobhya)—the names
f the Four Dhyani Buddhas mentioned in the
utra of the Golden Light. But there is no certainty
bout this, since it was more customary to place
atues of another group of Buddhas—Shaka,
mida, Yakushi, and Miroku—in pagodas, and

this may well have been the case at the Saidai-ji.
In this book, that statues are given the latter set of
names.

Although the styles and techniques displayed in
the Saidai-ji Buddhas are unquestionably those of
the Nara period, all four of the statues seem slightly
rigid and lack the freedom and expansiveness of
the best works of the time. Since this failing is char-
acteristic of works of the late Nara period, it seems
logical to date these statues at some time between
770 and 780. The benignity of their facial ex-
pressions marks them as works in the Todai-ji
tradition.

THE GIGEI TEN AT The statue of Gigei Ten,
THE AKISHINO-DERA a patron divinity of the
 arts, is one of a group
housed in the Akishino-dera in Nara (Figs. 106,
124, 165). The other statues in the group are those
of Bon Ten (Fig. 107), Taishaku Ten (Fig. 105),
and the Bodhisattva Gudatsu. As we have already
noted, the heads of the statues are dry-lacquer
works of the Nara period, but the bodies are wooden
restorations dating from the Kamakura period. The
heads are characterized by relatively strong facial
expressions, although they are marred by a rough-
ness that marks them as works of the late Nara pe-
riod. The Gigei Ten is the most beautiful of the
group, but even its beauty has a quality that sug-
gests approaching age—indeed, a quality that
shows it to be a product of declining artistic vigor.
Again, the fin-de-siècle character of all the statues
in the group is indisputably proved by the coarse-
ness of the dry-lacquer work, which falls well below
the level of such work in the most flourishing age of
Nara-period art.

TITLES IN THE SERIES

Although the individual books in the series are designed as self-contained units, so that readers may choose subjects according to their personal interests, the series itself constitutes a full survey of Japanese art and will be of increasing reference value as it progresses. The following titles are listed in the same order, roughly chronological, as those of the original Japanese editions. Those marked with an asterisk (*) have already been published or will appear shortly. It is planned to publish the remaining titles at about the rate of eight a year, so that the English-language series will be complete in 1975.

The "weathermark" identifies this book as a production of John Weatherhill, Inc. publishers of fine books on Asia and the Pacific. Supervising editor: Ralph Friedrich. Book design and typography: Meredith Weatherby. Layout of illustrations: Sigrid Nikovskis. Production supervision: Yutaka Shimoji. Composition: General Printing Co., Yokohama. Engraving and printing of color plates: Mitsumura Printing Co., Tokyo. Monochrome letterpress platemaking and printing and text printing: Toyo Printing Co., Tokyo. Binding: Makoto Binderies, Tokyo. The typeface used is Monotype Baskerville, with hand-set Optima for display.